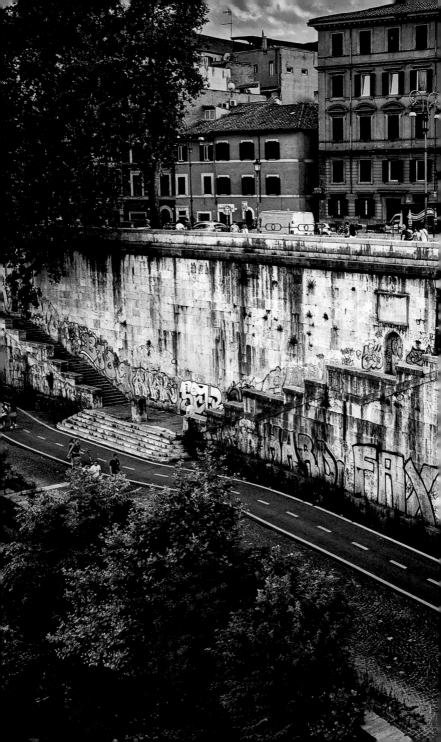

JEANNIE
MARSHALL

LEARNING TO LOOK
IN THE SISTINE CHAPEL

With photographs by Douglas Anthony Cooper

BIBLIOASIS | WINDSOR, ONTARIO

FIRST EDITION 10 9 8 7 6 5 4 3 2 1

"What He Thought" © Heather McHugh, 1994. Reproduced by kind permission of the author.

Library and Archives Canada Cataloguing in Publication
Title: All things move : learning to look in the Sistine Chapel / Jeannie Marshall.
Names: Marshall, Jeannie, author.
Description: Includes bibliographical references.
Identifiers: Canadiana (print) 20220461155 | Canadiana (ebook) 2022046118X | ISBN 9781771965330 (hardcover) | ISBN 9781771965347 (EPUB)
Subjects: LCSH: Michelangelo Buonarroti, 1475–1564 — Criticism and interpretation. | LCSH: Cappella Sistina (Vatican Palace, Vatican City) | LCSH: Mural painting and decoration, Italian — Vatican City. | LCSH: Mural painting and decoration, Renaissance — Vatican City. | LCSH: Art and religion — Italy.
Classification: LCC ND623.B9 M37 2023 | DDC 759.5 — dc23

Edited by Daniel Wells
Copyedited by Rachel Ironstone
Cover and text designed by Natalie Olsen

Published with the generous assistance of the Canada Council for the Arts, which last year invested $153 million to bring the arts to Canadians throughout the country, and the financial support of the Government of Canada. Biblioasis also acknowledges the support of the Ontario Arts Council (OAC), an agency of the Government of Ontario, which last year funded 1,709 individual artists and 1,078 organizations in 204 communities across Ontario, for a total of $52.1 million, and the contribution of the Government of Ontario through the Ontario Book Publishing Tax Credit and Ontario Creates.

PRINTED AND BOUND IN CANADA

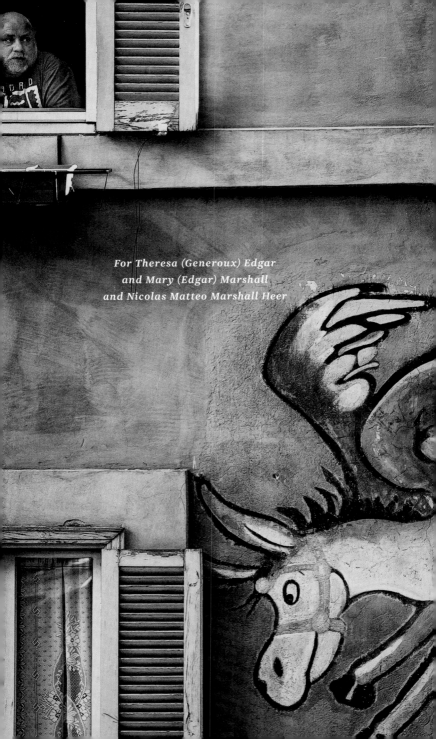

*For Theresa (Generoux) Edgar
and Mary (Edgar) Marshall
and Nicolas Matteo Marshall Heer*

CONTENTS

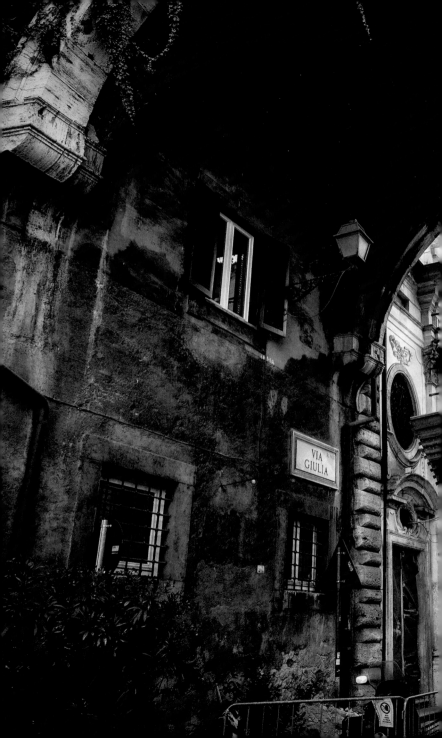

PREFACE

Returning

It was early June, a humid morning heavy with dark clouds. The occasional fat drop of rain splashed down on the sidewalk, on my head, and on my shoes while I walked slowly, savouring the relative quiet of Rome's normally busy Via Ottaviano. The side entrance gate leading toward the Basilica di San Pietro — Saint Peter's — lay straight ahead. Any right turn along this stretch from the Metro station before reaching Piazza del Risorgimento would take me closer to the Vatican Museums. In the past, I just followed the crowd, followed the touts and tour guides. But on this morning, on this almost empty stretch of sidewalk, I had to think about where I was going. This once familiar city now felt a little foreign. And so, weighing the options, I chose to turn onto a street with a coffee bar where I could drink a cappuccino before carrying on.

This was during that hesitant period in 2020, while we were still absorbing the shock of a pandemic, and

when we didn't know how to think about the future.
Both the Vatican Museums and I had only just been given
our liberty, or at least a measure of it, after nearly three
months. The museums, along with the Sistine Chapel, had
only reopened a few days earlier, and I was still getting
used to going out beyond my own neighbourhood. I'd
grown accustomed to wearing a mask over my nose and
mouth, but I wasn't yet used to the freedom to walk into
a bar and order coffee. I sat outside under an umbrella,
protected from the lethargic rain, and waited until the
barman placed the cup on the table before removing my
mask. I wanted to hold on to the moment and remember
what it felt like to be out in the world again, but it didn't
feel as I expected it would. It felt dangerous, and I felt
anxious, as though the world had revealed itself to be
something fragile, unstable, and unreliable.

I went inside to pay and saw that the barman was
just drying his freshly washed hands on a paper towel.
He pulled on a new pair of latex gloves before taking
my money. We wished each other a good day. And good
health, too, he added. I sincerely wished him the same.

Everything about that morning was different. The
sidewalk in front of the high, fortress-like wall that
marks the perimeter of Vatican City was empty where
it used to be packed with people waiting to enter the
museums. A guard looked at the booking code on my
phone and sent me directly inside along with a few other
people. And though I was looking forward to wandering
those halls and rooms without the usual crowd, though

I had longed for years to see the Sistine Chapel frescoes without being squashed and trampled, I felt a sense of loss, as though the chapel, having been locked and left empty for weeks, had also revealed something about its fragility.

Perhaps I hadn't completely understood before the extent to which the meaning in Michelangelo's frescoes lies in me and in all the people who come to see these images, that it is not fixed like the pigment in the plaster. Michelangelo painted the ceiling from 1508 until he finished in 1512, and then after a gap of more than twenty years in which he witnessed war and plague, he returned to paint *The Last Judgement* on the altar wall in 1536. He changed after that experience, and I have changed too. Anyone who visits the Sistine Chapel after this disruption in our world will bring that corresponding event into the room. And meaning, ever shifting, will change, and we will have to acknowledge that we, and it, continue to reach toward each other struggling to understand something that will not hold still.

The historical interpretation, the agreed upon story of what is being said in these images is only part of the process of discerning what it all means. To stand in the room and look at the images and allow them into your life, to wrap themselves around your own memories, and to feel what a great work of art means to you is another thing entirely. To revisit after a big event in your life or in the world provides an opportunity to see the changes in you reflected in it.

I wandered through the museums, through the gallery of paintings, outside on the terraces, and down the long corridors, and when I finally reached the stairs just outside the Sistine Chapel, I stopped and took a picture because I'd never seen them empty before.

And then I went inside.

There were only about a dozen people in the silent room, all wearing masks, keeping their distance from each other, and trying to look straight up without falling over. These were the ideal circumstances that I had been dreaming about, though I was sorry it took a pandemic to clear the room and allow me to finally have a good look at the ceiling and the altar wall.

The others also seemed a little overwhelmed by the opportunity to visit this room in peace. I found myself thinking about all the times I'd come to this chapel, all the evenings I'd spent looking at images of the frescoes online and in books. This time I was immediately drawn to the figure of Mary next to Christ in *The Last Judgement*. The dominant colour in that enormous fresco is blue, but the blue of Mary's robes, which appear to be tossed over her legs like a blanket, appears reflective and shiny. I was drawn straight to her, as though the whole thing had been about her. And for the first time I thought, yes, in a way, for me it really has been all about her, about the way that learning to construct meaning is passed down from past to present, from mother to child.

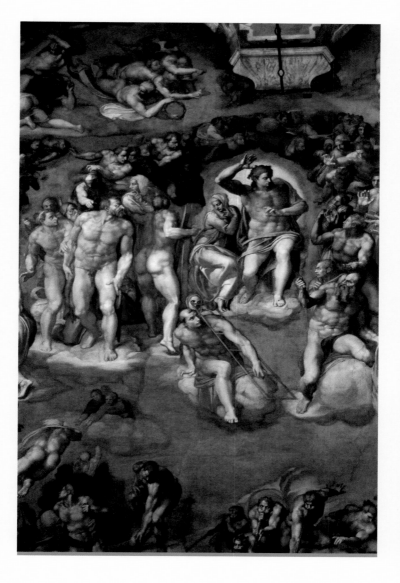

Something has happened to interrupt the flow of ordinary life, and it reminds me of how often the flow has been interrupted before. In saying that Italy experienced plague, experienced it during Michelangelo's tenure in Rome, and then moving on to talk about the altar wall fresco, I am moving too quickly. I have more of a feeling for that kind of calamity than I did when I first visited the Sistine Chapel. Plague and war were the existential threats that too often decimated populations in the Renaissance era. Perhaps such threats helped to reinforce ideas of eternity after death when this life seemed less certain. Michelangelo's return to the Sistine Chapel after such destruction was a show of faith in art as much as anything. For me, returning to see it is a show of faith in this work of art's capacity to point backward and then forward in time, to sweep me up and make me feel more connected to a bigger human project than I ever imagined was possible before I decided to pay attention to the Sistine Chapel frescoes.

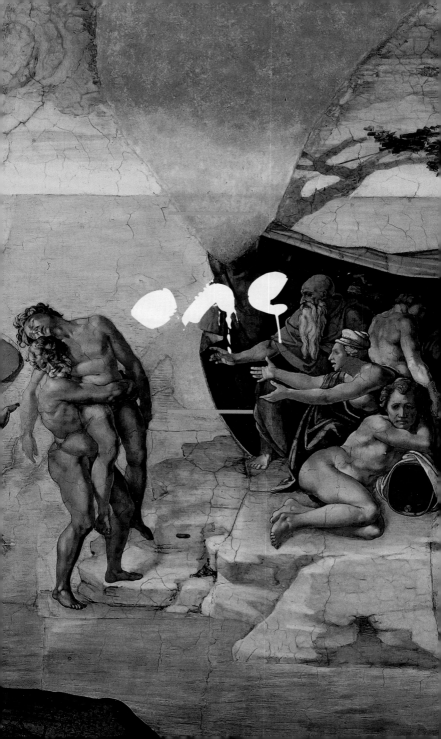

THE CENTRAL PANELS

PANELS

In the Beginning

I made many visits over a few years, enough that I lost track of how often I'd gone. But it wasn't until the third time I visited the Sistine Chapel that it all started to change. It was March, and the shifting season offered its familiar hints of renewal. No matter that the seasons change and spring arrives every year, I can't help but respond to it with optimism. And so I set out that morning for Vatican City on a whim, without any heavy hopes or sense of obligation. I had an unexpected free day, and I thought *why not?* I made my way through the rooms and corridors of the Vatican Museums, trying not to linger, trying not to engage too much too soon and risk ending up exhausted before I even got there.

When I stepped into the Sistine Chapel that morning it was quite full, though not as jammed as the first time I saw it the summer before, when the space felt hot with the exhalation of hundreds of miserable souls.

It was still full enough that I bumped into people and they bumped into me as we moved around with our heads bent uncomfortably backward. A couple of women sat on the floor and leaned back to stare at the ceiling more comfortably, but an official, known unofficially as a shusher, indicated that they should rise. He and other shushers moved through the crowd of upturned faces whispering "shush" and "silenzio," reminding us that the Sistine Chapel is a place of worship and not an art gallery.

A priest quietly asked a middle-aged English woman, who was with another middle-aged English woman and two young children, to stop taking photos. "Why?" she asked, not quietly. "Because this is a holy place," he answered. "I still don't see why," she said to the other woman as the priest moved on. "It's not hurting anything."

"They just want you to buy the postcards," said the second woman.

A man looked down at his shoes and muttered to his companion that he needed to get out of there, he needed coffee, he'd seen enough, let's go already. A woman pointed to the central panels and said to her young companion, "Look at that, that's famous. And there, that's famous." She indicated Adam in the centre, "Oh, and that one's really famous."

"Shush," said the shushers. "Silenzio."

When the art critic Robert Hughes came to Rome to work on his last book, which was all about the city's art and architecture, he visited the crowded Sistine Chapel and he, too, fretted a little about the difficulty of seeing

it, in part due to the behaviour of other people. He urged museumgoers everywhere to relax in front of a piece of artwork, to look at it quietly, to notice the details, allow your eyes to wander over a painting or sculpture, and keep your thoughts to yourself. It doesn't have to be a reverential silence, just allow yourself to quietly contemplate the work in front of you and "just shut the fuck up, please pretty please."

I tried to obey Hughes's orders while resisting an urge to quote him loudly.

I had only recently begun looking at this famous frescoed ceiling. Living in Rome means I can go with relative ease and almost whenever I want, and yet for a long time I didn't. I never quite felt up to the intellectual challenge: I didn't want the experience to be superficial, but I didn't know how it could be otherwise. When friends mentioned having seen the Sistine Chapel, I felt an aversion to even listening. I had a sense that religious art could have nothing to say to me, that its concerns were not mine. In fact, I felt a twinge of unexamined hostility toward the Christian content of Michelangelo's frescoes, while at the same time I wanted to understand their artistic merit. There was apprehension mixed into it, too, and the slight concern that these frescoes might be genuinely meaningless in the twenty-first century to a person like me, though I preferred to think that I wouldn't understand them than to think there was no longer anything there to grasp. In sum, I was conflicted, and for a long time it didn't seem like a conflict I really needed to resolve.

I FIRST VISITED ROME IN 2001, and then I moved here with my boyfriend, who is now my husband, the following year. Our first apartment was on Via dei Foraggi, a short street that leads to the ruins of Ancient Rome. We spent all our free time exploring the city and walking the cobbled streets of the centre. We saw the Colosseum, the Palatine, and the Pantheon. We saw gallery after gallery, museum after museum. We took the train to Florence to spend a day in the Uffizi. But we didn't see the Sistine Chapel because the lines were endless, and our patience was not.

James had seen it long ago when he was travelling with friends back before it was restored, when it was dull and grey from time and lamp oil. He didn't feel a pressing need to stand in a long line to look at it again. I bought a fold-out reproduction in Vatican City to study up for a future visit. I tucked it into a book where it stayed on the bookshelf until I packed it, numerous times, still inside the book, and then unpacked and re-shelved it. The reproduced images of the Sistine Chapel frescoes stayed where I had put them as the ordinary business of life took over, as our sightseeing tapered off, as we worked, as we had a baby, and as we moved through several apart-ments over the years, packing and unpacking our boxes, and as our son grew bigger, until we moved to another new home. About twelve years after I bought that booklet, it fell out as I was unpacking boxes once again.

It had a blue border and an image of God creating the sun, the moon, and the planets. The moment I saw it, I remembered the feeling of those early days and weeks in Rome, of a sense of endless discovery and all the time in the world. I remembered the sense of shared adventure I felt with James about moving to Italy. I remembered the sense of anxiety, too, about the unknown, about changing our lives' direction. He had left a career as a documentary filmmaker in Toronto to start something entirely new with the United Nations. I had left my job as a journalist at a newspaper to become a freelance writer. I saw the booklet on the floor, and I felt that fluttering of excitement again. I also felt those old fears in my hands, as though my fingers had stiffened around something. I no longer felt that there was all the time in the world.

I remembered that I had always intended to go to the Sistine Chapel once I was ready, once I had studied up on it. But it never seemed like the right time to take on such an enormous symbol of Western culture. It seemed like such a lot of bother just to get tickets and enter the building. I could hardly bear the thought of standing amongst a crowd only to look at something that seemed simultaneously too complex to be understood just by looking at it and too worn out from overexposure. It was both unknowable and too familiar. The combination produced a feeling of apathy, which made me defer my visit again and again.

When friends came to Rome, I would accompany them all over the city. When they wanted to see the Sistine Chapel, I told them they were on their own.

But then a few months after we moved into that apartment in 2014, my mother died. She was old by then, eighty-eight, and she had been suffering. I thought her death would feel like a relief, but it didn't. I spoke to my brother Dan on the phone that night. It's an ending, he said, but it's still a loss. It's not a relief, we both agreed.

Maybe the two events are unconnected, but it was only a few weeks after my mother's death that I visited the Sistine Chapel for the first time, after all those years of not going. After all those years of living in a city that still shows the beauty of having been touched by Michelangelo — the arch connecting two buildings on the Via Giulia, the shape of the Campidoglio, and the stairs that I can see from the window of the bus I take home from the city centre, those stairs that look like cascading water running down to the street below — it started to feel like I should go. Where I previously felt like it might be a waste of my time and that the Sistine Chapel frescoes would be wasted on me, I began to feel that it was time, and that I ought to go and see what I could make of them.

I searched for advice on how to approach the Sistine Chapel and found little that was truly useful other than Hughes's suggestion that we all just keep our mouths shut and our eyes open.

When I finally went to see the ceiling for the first time in early summer, when the heat in Rome was just beginning its seasonal torment and the crowds were nearly at their peak, I couldn't see it. The room was crowded, the

shushers were shushing, the frescoes were more than twenty metres above. I put glasses on, I took glasses off. Whatever trouble I had seeing the ceiling, it was not related to my eyesight.

On that first visit, when I made my way through the Vatican Museums, up the stairs, and over the very ordinary threshold to enter the Sistine Chapel, it over-whelmed me. I was aware of a heightened sense of expectation because I knew I was about to see something so revered, so important, and after all those years of putting it off I was still quite unprepared. I entered the crowded room and tried to find a place among all the squirming, sweating bodies as the shushers tried to keep people moving toward the exit. I planted myself in the middle of the crowd and stubbornly looked upward.

My first experience was not pleasant and was certainly not what I expected. I knew the ceiling's central narrative; I was familiar enough with the panels that tell stories from the book of Genesis. There He was, God, creating the universe in the first three panels, and then in the centre is the infamous image of God animating Adam with His outstretched fingers, and God pulling Eve out of Adam's side, and then the expulsion from the Garden of Eden. At the other end of the chapel from where I had entered are the panels telling the story of Noah and the flood. I could see them, but I didn't feel anything other than irritation and confusion. It all seemed in motion. The central panels are surrounded by so many other images, and I knew I would have to

understand the peripheral stories, too, if I was going to understand the centre. It all seemed too much, too enormous, and too religious.

My first experiences in the Sistine Chapel were so unsatisfying that I felt I had to return, I had to be missing something. This sense of personal failure, the feeling that there was something important just beyond my grasp, meant that I couldn't let it go. I have always liked the idea that John Berger articulated in his influential *Ways of Seeing* that we really need to see the art of the past to situate ourselves in history. The images in the Sistine Chapel are not simply biblical illustrations; they are also the product of an intellectual culture, of the ideas of one of the most influential artists of the Renaissance, and of the consequences of historical events. Out of a sense that seeing this work could yield some insight into the past and the present, that it could lead me to see something of the world of now that we all inhabit and that world in relation to my own life, I decided to persevere. I was finally ready to be situated.

And that's why I happened to be there again for a third visit at the beginning of spring the following year, still struggling to see the thing I keep looking at, still watching the people in the room to see how they take in such an enormous and historically significant work of art, still wondering if it is as much of an enigma to others as it is to me.

The priest stopped trying to quiet the crowd and made his way to a microphone near the entrance to recite a

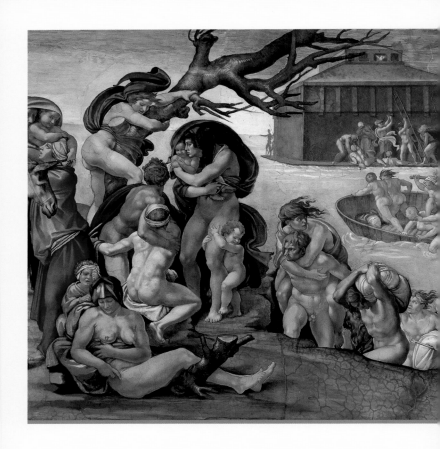

prayer in Italian. The English woman snapped a photo
of him then turned and, as she left, pointed her camera
toward the three panels that tell the story of Noah.

I managed to get a seat on a bench under the scene
of the flood where I could rest my head against the wall
while I looked up. *The Deluge* is the end of the story, the
end of the world as Noah knew it. Though this is the last

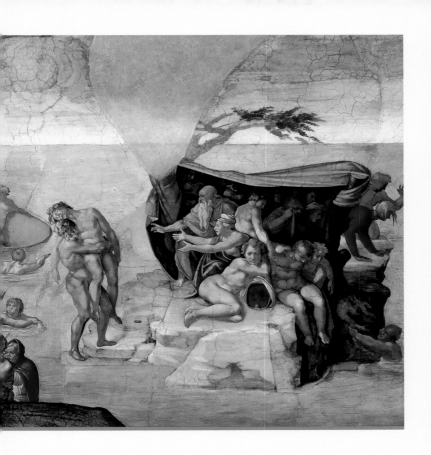

of the sequence of central panels, Michelangelo painted
it first. He painted the destruction of the world before
painting its creation. He considered himself a sculptor
rather than a painter, and art historians speculate that
he wanted to warm up before he painted God.

I tried to find my way into this image by noticing
the details that I had read about before I came to visit,

details such as the white patch in the sky where the plaster fell off in 1797 when the gunpowder depot at Castel Sant'Angelo exploded. Though it's hard to see from below, a woman carries a jug nestled between the legs of a table that she has balanced upside down on her head as she walks out of the water. Michelangelo had a similar jug in his own kitchen. These facts allowed me to focus on a few particulars, providing a way into this part of the fresco.

But then, as I looked at the people struggling to get out of the water, it occurred to me that they're not survivors, as I had so lazily been thinking of them. No one who isn't in the Ark survives this flood. These people are about to die. The water is rising. This image captures a moment when they still have hope, but we know their hope is misplaced because we know this story. In these circumstances, the table and the jug will be useless to the woman who has gone to so much effort during her last moments on earth to carry them with her. The mother and her children will not survive. They don't know it yet, but we do. Everything that seemed important before the flood is now inconsequential, and yet there's a woman carrying a table and a jug.

"I will destroy man whom I have created from the face of the earth; both man, and beast, and the creeping thing, and the fowls of the air: for it repenteth me that I have made them." This is what God says in the King James version of Genesis and the story of the flood. These people had become wicked, He says, and their hearts evil.

"The end of all flesh is come before me; for the earth is filled with violence through them; and, behold, I will destroy them with the earth," says God to Noah when instructing him to build the Ark.

But Michelangelo doesn't depict these people as God describes them, and instead we see people emerging from the water naked and vulnerable, helping and carrying each other, rescuing a few practical household items in the hope that their lives will continue, and they will need them. It's the artist's sympathy for God's victims that made me see them as survivors before I thought about the story. It's our tendency to identify with Noah and his family, the actual survivors, but this depiction causes us to consider the fear and anguish and even the humanity of the condemned.

"Seen through half-closed eyes, *The Deluge* resembles a picture that has been partly whitewashed. The world is a picture that God can unpaint at any moment," wrote art historian Andrew Graham Dixon, who seemed, like me, to be transfixed by these shades of grey. I had read that line before I ever saw the fresco, but now I could see how the artist painted the sky meeting the flood water in a way that obliterates them both, as it does in reality in the pale light of a storm. He used the same shade for the sky and the sea, a pigment made by friars in a convent in Florence from roasted cobalt and glass and then ground, likely by one of Michelangelo's assistants, until it reached this deathly pale blue verging on grey. This panel is more detailed than the other frescoes and

is even harder to see from the ground than most of them. But, resting on the bench in that room, looking at the blue-greyness of the water, the sky, and the clouds, I thought of a smothering, airless nothingness.

The sounds of shuffling feet and murmurs fused into a hum, the movement of people around me changed character and became like a slowly swelling wave that never crests but only dissolves before it swells again.

It's one thing to know the story of the flood and another to feel it, to feel the loss of anything like hope or future and to sense the blunt force of finality. Annihilation is in the midst of happening in this image. But this is destruction by God, and this image tells us to seek redemption, to change our lives or we'll soon be dragging ourselves and our useless possessions onto a shore that will not save us. Do it now while there is still time. There's something menacing, wrathful, and angry going on up there and it feels like a warning. I shivered while I watched my fellow men and women stumbling about underneath, looking up to the ceiling and tripping over other people, looking down to find their way but missing what's going on above.

All these people in the chapel had their own reasons for being there. Some were devout Christians, some were art lovers, some were checking it off their list of touristic sights. I still wasn't clear about my own vague motivations. We all want something from the Sistine Chapel. We want to understand it, but we also want some of its glory sprinkled upon us like holy water. We want

to take hold of the messages painted into the plaster, to gain some insight into life here on Earth, and to figure out how to live. We want to be people who have seen the Sistine Chapel. But even our shallower motivations lie on top of something more profound—the desire to see and be touched by greatness, and to discern its meaning in our lives. When we arrive, if we're really looking, we'll see that Michelangelo is not showing us something beautiful, though there is beauty in it, but horror and destruction, the possibility that all our worldly concerns are pointless, that if the world ceased to exist, both our most precious and utilitarian objects would amount to nothing. We were nothing and will be nothing, "For dust thou art, and unto dust shalt thou return." Michelangelo blends the sea and sky at the horizon into a void, an unbearable emptiness.

Yet, to recognize that void is somehow thrilling. As I sat there, head against the wall and mostly oblivious to the irritation I was causing by taking too much time on the bench, I felt like I'd experienced something essential and terrifying.

At that extreme moment of isolation, I felt like the ant who has suddenly grasped the colony; I felt a part of something much bigger than what I can see, yet also alone. By staring and staring at this ceiling, I was struggling toward an answer to a question I hadn't properly asked. It brought forward childhood fears of a vast and incomprehensible universe, of seemingly senseless violence in the world, and of the anger and the

anguish I'd seen in people I loved. The need to control my own life seemed crucial, and my ability to do so felt impossible; any thought that I was in charge seemed in that moment to be shamefully arrogant, and so the answer to the question of how to live seemed to slip in and out of my hands. The idea of existence was outrageously unlikely: How is it that all the men, the beasts, the creeping things, and the fowls of the air exist, and how do I? And since we do exist, shouldn't it all mean something? Though, woven into that question is the fear and the dread that none of it means anything.

When I first visited the chapel, I wondered if such a work could still be relevant five hundred years after it was painted in a city that was so defined by Catholicism. Yet, until the pandemic interrupted the flow, more than five million people would come every year from all over the world to see it. They didn't all necessarily know the stories of the Old Testament, but mortality hasn't changed, eternity and the void have not changed. We still don't know who we are, where we come from, or where we're going.

After staring at the central panels and studying *The Deluge*, I left the chapel with a sense of having glimpsed something more elemental than myself. The whole of human history, the idea of civilizations and of human beings collectively and individually striving toward something obscure all seemed stirred into the paint and given substance in the mist, the clouds, and the chaos of these images of creation and destruction.

But I also left with a new sense of wonder mixed with dread that shattered any idea I might once have held of art as universally pleasing and improving. What I experienced wasn't therapeutic, gentle, or restorative. I was elated, and my thoughts were bouncing wildly. I felt that stiffening in my hands again, as though they were tightening their grip on something, and my palms were sweating.

I walked out of the chapel and immediately into the part of the building with exit signs and fire extinguishers. As we made the long walk through the rooms and corridors, I asked a few people what they thought, and if any of them felt as overwhelmed as I did this time. They used superlatives: "amazing" and "incredible" and "stupendous" and "breathtaking." But even those who'd taken the audio guide didn't seem to know that the central panels represent the stories from Genesis. It was a first visit for all of them, and they weren't yet able to see beyond the work's reputation or through the fog of its fame. My questions were impossible for them to answer because this is a work of art that takes its time. It asks the viewer to work, to see what is represented on the ceiling above, to consider these depictions of once commonly known Biblical stories, and to see that despite the superficial differences between ourselves and a Renaissance-era Roman or Florentine, the conditions of our existence are still the same.

It was well past noon, and my fellow museumgoers were more interested in finding lunch than in talking

about Michelangelo's masterpiece. I recommended they leave this area with its tourist touts, its gift shops selling rosaries and Vatican shot glasses, its criminally soft pasta served atop tables covered in anachronistic checkered cloths. I suggested they take a long walk through the narrow streets of the centre, past Bernini's fountains and Bramante's church and keep going to the point where the old city encounters the modern reality of Chinese restaurants and halal butchers. I told them to ask for a table at Trattoria Monti, where the waiter would give them an elegantly shaped flask of white wine from Le Marche and was sure to suggest they try the pasta with anchovies, raisins, and sharp pecorino. I hoped they'd eat the fish pasta that they thought they wouldn't like, that they'd let the wine take the edge off the day. And then I imagined they'd leave the restaurant, and they'd notice the third-century triumphal Arco di Gallieno now nestled into the church of Santi Vito on one side. After they walked through the arch, I hoped they'd notice all the shoes outside the door to the building that attaches both to this ancient gate and to the fourth-century church and that leads to a prayer room, a make-do mosque. Perhaps the visible flow of time and turmoil might make them pause. It might even compel them to go back to the Sistine Chapel for another look. I wondered if they might feel, as I was beginning to, that life on the street was still related in some fundamental way to the art in the churches, chapels, and museums.

IF I WENT INTO THE SISTINE CHAPEL thinking
I was going to crack the code on art, a few visits later
I was even more confused. I was beginning to find my
way into parts of the fresco, but I didn't understand
the reaction these images were provoking. They were
familiar, but that's not surprising. It was just that some
of them were familiar in a way that felt bewilderingly
personal, as though they gestured toward something I
must once have known. I didn't recognize all the images
so much as I recognized a feeling connected to them.
They were equal parts comforting and menacing, and
at the time none of it made sense.

I turned to neuroscience, as we inevitably do these
days, hoping for a simple scientific explanation for why
human beings are drawn not only to making art but to
viewing it. I found a study that examined the reactions
in the brains of people who were looking at the Sistine
Chapel ceiling, at the panel depicting Adam and Eve
being expelled from paradise by an angel with a sword.
The researchers found that the image, which shows
Adam making a feeble gesture with his hand bent at the
wrist to ward off the angel's jabs, stimulates the areas
of the primary motor cortex that controls our wrists.
We feel something of what we're seeing.

I found that none of it explained the vertiginous
sensation that the horizon line in the flood panel
provoked in me. I don't doubt that I'd felt something of
what I was seeing, but why did that image, particularly
that bit of sky and sea, which is really the depiction of

nothingness on a ceiling that is saturated with colour, flesh, and objects, why did that little greyish patch provoke my primary motor cortex into placing one of my actual hands on top of the other to massage and uncurl my fingers, to dispel the need to grasp hold of this unseen dread and squeeze it?

It makes me wonder if some part of our brain still reacts as it did in a time before there were images. There was a time when if you saw a huge bison before you it was because there was a huge bison before you. Perhaps there is a lag where the part of our brain that originates with an earlier iteration of humanity thinks there is an angel with a sword coming toward us, while our conscious brain knows it's just a picture. Maybe there is a little twitch between the brain that thinks an image is true and the brain that knows it's not. The feeling lingers, perhaps, because even though we can see that the danger is not immediate, we can't shake off the sense that it's out there.

One of the most famous descriptions of the conscious brain being overwhelmed by a visceral reaction to art comes from the writer Stendhal. He wrote in his journal that he arrived in Florence on January 20, 1817. He had been living in art-rich Italy as French consul in Trieste and Civitavecchia since 1814 and yet two days after arriving in the city that is synonymous with the Renaissance, he was physically overcome by Volterrano's ceiling frescoes and the tombs of Michelangelo and Galileo that he saw in the Basilica di Santa Croce.

"The tide of emotion which overwhelmed me flowed so deep that it scarce was to be distinguished from religious awe. The mystic dimness which filled the church, its plain timbered roof, its unfinished façade — all these things spoke volumes to my soul. Ah! Could I but forget," he wrote.

Stendhal continues to describe his experience with a mixture of agonizing delight and terror.

"Absorbed in the contemplation of *sublime beauty*, I could perceive its very essence close at hand; I could, as it were, feel the stuff of it beneath my fingertips. I had attained to that supreme degree of sensibility where the *divine intimations* of art merge with the impassioned sensuality of emotion. As I emerged from the porch of *Santa Croce*, I was seized with a fierce palpitation of the heart...; the well-spring of life was dried up within me, and I walked in constant fear of falling to the ground."

The term Stendhal syndrome wasn't coined until the 1970s, when Dr Graziella Magherini used it to describe the tourists in Florence who ended up at her hospital suffering panic attacks and temporary bouts of madness after visiting galleries. They all attributed their symptoms to the art. In a recent interview, Dr Magherini explained that the syndrome often occurred in tourists because they were already unsettled from being away from home, and that this left some of them open and vulnerable to a place that was filled with history and historically significant artworks. She believes that we inherit the past unconsciously, our own past but also

our collective history, and the panic attacks that she saw among tourists were a manifestation of this encounter with history and art together. "It's important to underline the connection between art and the psyche, to see how significant it is to know the traces of the past," she said.

That people experience such a physically overwhelming response to sculpture and paintings that we usually describe as simply beautiful suggests that art affects us at a level beyond the conscious. Dr Magherini described it as knowledge of the past inherited by our nervous systems. Beauty is only the surface of the artwork, the thing that makes you look, but when you really look you might sense that there's something more in it than you were expecting. Sublime beauty and divine intimations of art sound like desirable sensations, but Stendhal wished he could forget what they felt like. Art is provocative, and what it provokes isn't necessarily comfortable.

In fact, it can be violent. The twentieth-century painter Barnett Newman created a series of paintings called *Who's Afraid of Red, Yellow and Blue*. Newman placed himself on a continuum with past masters, with the early abstract art of Mondrian in this case because of his use of blocks of colour, and he saw himself in a line with the greatest painters in Western art. "If I am talking to anyone," he once said, "I am talking to Michelangelo."

The fourth painting in the series was attacked in the Nationalgalerie in Berlin in 1982. Though the attacker told police he was angry that the gallery would pay 2.7 million Deutschmarks for something he thought he could paint

himself, he might have been responding with more than simply taxpayer outrage. He also told them that when he stood alone in front of the painting, which consisted of a block of red paint and a block of yellow separated by a thinner band of blue down the centre, he sensed Newman's tremendous power and was overcome by fear.

Newman believed in the sublime, an enduring aesthetic concept dating back to the writer Longinus, who lived in either the first or the third century CE. Though Longinus focused on the sublime in writing, the concept he first articulated grew as others adopted it to include a particular kind of encounter with art or nature that is not only awe-inspiring but also terrifying in a way that evokes Stendhal's experience in Florence and even my own experience of *The Deluge* in the Sistine Chapel. Longinus wrote that great writing was created by men who were "superior to what is merely mortal;... sublimity raises them near to the greatness of soul of God."

Newman made a distinction between pictures and paintings. Pictures were images of objects and people, whereas paintings were objects in themselves. The force in an abstract painting such as the kind that he made did not come from what it represented but what it was. Newman's use of vertical lines in so much of his work has been described as an attempt to rip open the universe. Michelangelo was trying to make the spiritual visible in pictures, and Newman was trying to make it palpable with paintings.

In 1986 in a Dutch museum, a vandal sliced the canvas of the third painting in Newman's series. The same person came back eleven years later and slashed another of Newman's paintings, *Cathedra*. A woman in France kissed a Cy Twombly triptych in 2007, smearing it with lipstick in what she called an impulsive act of love. And in 2009, a Russian tourist threw a gift-shop mug at Leonardo da Vinci's *Mona Lisa* in the Louvre. The painting was undamaged because it's protected with bulletproof glass, which makes a person wonder why a painting needs protection from bullets.

THAT UNCONTROLLED REACTION, the one we often call our gut reaction, is the one I find interesting. I've never wanted to throw something at a painting or to damage a piece of art, but I have felt things I didn't expect to feel in front of artworks. The first time I saw Mark Rothko's painting *Red, No. 5* in Berlin, I couldn't stop staring at it. At first, I noticed the way the red paint looked

rough and unblended. There was a ragged quality to it.
And within a few seconds, I was overcome with sadness,
an unexpected sense of despair. The redness seemed
heartbreaking in a way that my rational self could not
understand.

I was alone in the gallery when that happened.
I had been alone in Berlin for a few months at that time,
and I think this had something to do with my reaction,
with my receptivity to this quality in the painting.
I had nothing but time, and I used it to meditate on
the melancholy this painting brought to the surface.

There's a famous quote by Simone Weil that ought
to be engraved above the doorway to all the world's
museums: "Attention, taken to its highest degree, is the
same thing as prayer." In Rome, where so much of the
art is in churches and so much of it involves religious
ideas, such attention can almost literally become prayer.

I like to notice the role of prayer and religious devo-
tion in my neighbourhood. I've long enjoyed watching
the older women who park their stuffed shopping carts
outside the church doors after a morning at the market
while they stop inside to pray for a few minutes. I'm
drawn to observing them as they observe a painting of
Mary or Jesus, the way they use the artwork to remind
them of their faith and to keep it alive in their minds.

I've watched them answer the bells calling them
to mass, I've seen them leaving flowers at the shrines
to the Virgin on the street. These rituals give their lives
a shape and meaning that mine, at times, has lacked.

Their apparent sense of duty in praying every day, their faith in a god that listens to them has always been appealing. It seems soothing and orderly.

Certainly, before I visited the Sistine Chapel, I was thinking about what it must be like to believe in something, to have faith. When I watched the women coming and going from the church, I imagined their faith as a simple pleasure, as something reliable, something that provides comfort when the existential questions come knocking in the middle of the night. I also saw it as something they shared with each other, which brought them together. If all of us believe in the same set of stories, we must all be right.

But every time I enter a church, I feel the sense of mystery there, and I know that having faith is a more complex, even artful way of existing than I have wanted to believe. Rather than soothing our existential fears, faith requires an ability to engage with ambiguity.

Even though I don't consider myself a Christian, I walk into a church at least once a week. Crossing the threshold of Santa Maria in Trastevere, an old favourite, is an act of moving from one world to another. Outside in the piazza, there's always a crowd around the fountain, sometimes musicians play for coins, children kick soccer balls against the adjoining stone wall of the church. Statues of the saints Callixtus, Cornelius, Julius, and Calepodius stand above the portico facing across the piazza toward the coffee bar, the restaurant, and the apartment windows.

My son learned to walk in this piazza, running round and round the fountain at its centre with other toddlers as they followed an ancient childhood instinct to circle. When the summer sun crested and the temperature reached the upper thirties, we'd seek shade under the portico, along with the Roma women who were helping the faithful fulfill their obligation to give alms to the poor. Nicolas liked to run his hands over the twelfth-century marble relief of a lion on a sarcophagus on the wall to our left as if he were paying his respects, and once he was finished, we would push open the heavy doors and go inside.

In *The Geometry of Love*, Margaret Visser describes the effect of entering a church called Sant'Agnese fuori le Mura in Rome. She writes that the contrast between the exuberant outside and the sombre inside is meant to remind visitors of a profound moment in their lives when they recognized themselves and God together. I went to visit Visser at her home in Barcelona just after she published that book. It was the year before I moved to Rome, and James and I were spending some time in Spain. I was writing an article about Visser's life in Spain, but we spent quite a lot of time in her living room sipping tea and talking about the effect of a church's architecture. She felt it elicited a response in the person who enters the church and helps them to find their way toward God, as though the artfulness of the place and the soul of the person could communicate about things that the conscious mind might want to suppress.

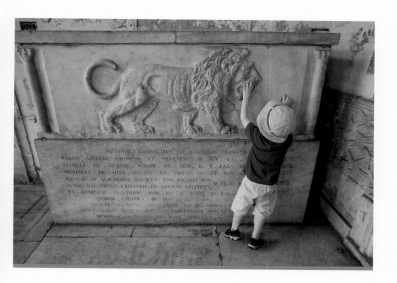

James and I had been walking in and out of churches
in Spain at that time, and we both had an inkling of
what she meant. On one of his first work trips to Rome,
James phoned me when I was still at home in Toronto
and told me that he went to Sant'Agnese fuori le Mura,
and he described the sensation of walking down into
the church — the entrance is below street level — and
into the darkness and feeling the sense of entering
another realm.

I still feel that moment of contrast whenever I enter
a church in Rome. I recognize the deliberate sense of
sanctuary created by the building's architecture, the
darkness, the quiet, and it does stir something up in me.

I see it on the faces of tourists who amble in looking only for shade and find themselves confronted with a hushed coolness and a weightiness that defies immediate explanation. I've seen it on the face of my brother Dan, who is about as non-religious a person I know.

Whenever I open the door of Santa Maria in Trastevere, I am reminded of a constant and underlying longing for connections between my isolated self and the world around me. And in that church, I have felt connected to my fellow seekers, all of us wordlessly looking for something to make sense of our lives. I have felt connected through the past to this very old church, and to all the unknown actions and movements since the beginning of time that have led to my existence and to that of the stranger standing next to me. It induces a sense of awe.

Outside Santa Maria in Trastevere is bright, hot sunshine; inside is cool darkness. Light from above filters through the stained glass images of the popes. The stone pillars draw the eye up to the wooden ceiling, the arches bring your attention to the nave and focus you on the apse and a shimmering mosaic of Mary and Jesus. Underneath are scenes from Mary's life made by Pietro Cavallini toward the end of the thirteenth century. Candles flicker in the corridors, their flames representing the energy of prayer for a loved one. The whole effect is powerful enough to subdue both me and, in the early days, my rambunctious child too.

Over the spring and summer that followed my third and more significant visit to the Sistine Chapel, I found

myself thinking about the way a church like Santa Maria
in Trastevere evokes a response every time I enter it.
It reminds me of my own smallness in the larger scheme
of the universe. I felt the same way while looking at the
encroaching void of Michelangelo's flood scene, even
though the void was more troubling.

I visited the church a few times during that period with a different intention. I felt that entering that space enriched the feeling I experienced with Michelangelo's void. It made me feel my own thoughts as if they had shape and texture, it slowed down my thinking, and my racing brain, always chasing the logical answer, had to run more quietly. The church itself hinted at other ways of knowing.

On one of those visits to the neighbourhood, I decided to go to the nearby Basilica di Santa Cecilia in Trastevere. It's brighter and entirely different inside, and I felt the need of a lighter atmosphere. I walked between the iron gates and into the sunny courtyard then under the portico and through the doors, savouring for a moment the transition, which was unexpectedly heightened this time by the sound of female voices. Eight nuns in black robes holding bibles and rosaries were singing together as one, all the words inaudible to me except for the rising "hallelujah."

Saint Cecilia is the patron saint of music. When she was forced to marry a nobleman in the second century CE, she sat apart from everyone at her wedding, singing quietly to God. In her honour, the sisters come into the church in the afternoons and they also sing to God.

I didn't want to shuffle around and disturb them, so I sat down, closed my eyes, and listened. Their unamplified voices filled the church. They sounded so human, so female, and young, even though six of them were bent with age. They were oblivious to the few people moving

around the church, their voices evoking the mystical and somehow also mirroring the pathos of Saint Cecilia herself, at least as she is depicted in the sculpture in a glass case below the apse, with her turbaned head twisted away from view and a deep, long slash along her neck, the wound of her martyrdom. From where I sat, I couldn't see the saint's marble image, but I knew she was there. Nor could I see the individual faces of the sisters. I could only hear them.

I'd been spending so much time looking at and struggling to understand Michelangelo's frescoes and trying to see the connection to the experience evoked by the art and architecture of churches themselves and then, without warning, this music enveloped me. And I let it; I accepted its intangible nature and experienced it without probing further.

I realized that the experiences I'd been trying to understand involve all the senses and can't be explained without some acknowledgement of that fact. The story of a piece of art is not a simple narrative.

The voices of the sisters in Santa Cecilia lift a corner of the everyday, of traffic and appointments, work and obligations, the life of amassing useless objects, and they move us toward what feels like the edge of the world. Under all this surface is something vast, they seem to be saying. Walk closer to the edge and peer over. You don't have to be religious, you don't need faith, you only have to be human.

WE CAN'T JUST WANDER INTO the Sistine Chapel the way Henry James did in the nineteenth century. We certainly can't take a nap there the way Goethe did in the eighteenth. The entrance is controlled, and visitors are encouraged to move through the room and out the exit even when it's not particularly crowded. James and Goethe were able to make a leisurely study of these frescoes. Our high opinion of this work comes from them and others like them, from people who could take their time in this room, to contemplate the artwork and spread its reputation.

One morning before making yet another visit, perhaps it was my fourth or fifth time, I stopped at my local coffee bar for an espresso. It was late May and I wanted to go before the crowds would become too thick. When I told the two barmen where I was going, they commiserated with me, as though I were about to undergo something painful. They had been there, of course, at various times in their lives, but wouldn't think of making regular visits. For them, it had simply become an extremely crowded tourist attraction. They couldn't imagine that it would be worth the trouble to go and see it, as though its meaning and importance had been worn out and overexposed.

I walked to the Garbatella Metro station and took a graffiti-covered train that smelled of burnt rubber to Termini station, where it was crowded with commuters and tourists, with Roma people and African refugees. I transferred to the A line, where the train was newer,

though no less dirty. A man with an accordion played "Bésame Mucho," a song I liked before I moved to Rome. He added a little flourish at the end to make it his own, then he pulled a crushed McDonald's cup from his pocket and walked slowly down the car.

I hate the accordions on the subway, I hate the clichéd music and the continual begging, but I fished a one-euro coin out of my wallet and dropped it in his cup. Something about the sadness of these men touches me, the way they look so weathered and time-worn, the slight impression they give of also having grown to hate "Bésame Mucho."

The train pulled into Ottaviano station, the doors opened, and I ran off and up the stairs to the surface, along the street, and past the tour guides offering the "most unforgettable experience of the Vatican Museums." I kept going, past the usual, lengthy lineup along the Vatican wall, to the shorter line for those who've paid an extra fee and ordered tickets from the Vatican website. I felt guilty as I rushed past the Belvedere Torso this time, and past the tapestries designed by Raphael's students.

I'd have liked to be transported directly into the Sistine Chapel without having to first navigate the disorder of twenty-first century Rome and the distraction of the Vatican's art collection. I'd have loved to arrive without accordion music in my head. But at that time, it was just how a contemporary visitor would come to see the greatest work of Western art.

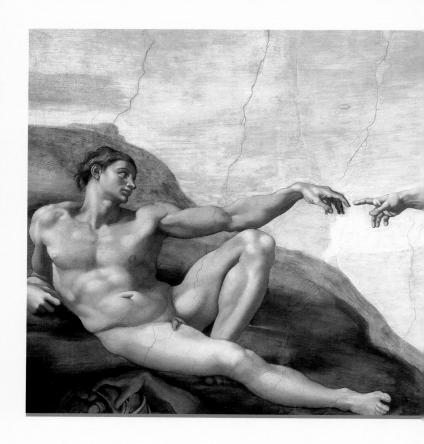

I pushed my way through the crowd and then looked up. I was directly under *The Creation of Adam*, the most well-known, the most reproduced, and likely the most parodied part of the entire ceiling. I arrived intending to study the figure of God from the first three sections but decided to go where the crowd had thinned. I've seen this image so often on postcards, I almost can't look at

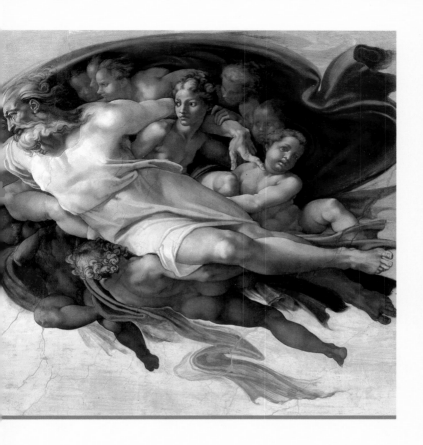

it now. There's a popular GIF showing God and Adam
in this famous pose but playing rock, paper, scissors.
I once ate a plate of spaghetti atop this image on a
disposable placemat, and the Vatican Museums' own
gift shop sells plastic placemats featuring God's hand
and Adam's. I found it hard to forget all that when
faced with the original.

Part of the reason it is so familiar is because it was once so singular. Some of the first people to see the Sistine Chapel didn't recognize the figure of the old man as God. In one of the creation stories in Genesis, a mist comes up from the earth, watering the ground, and God makes Adam from the soil and breathes life into his nostrils. Here, Adam is already fully formed and is simply being animated by the touch of God's hand.

This image is the victim of its own greatness. It is the hardest part of the ceiling to really see afresh. I stood under it trying to acknowledge that I was looking at the original image that inspired all those variations. In fact, this patch of ceiling is responsible for the idea of God in my own head.

IN THE MIDDLE OF THE SUMMER when my son was ten, I had a bad idea. It was hot, we were bored, and I thought we should visit the Sistine Chapel together. It was almost exactly a year after I had made my first uncomfortable visit, and I should have known better. I thought the effort might make it part of the adventure. Mainly, the opportunity was there, and he was still young and malleable enough to agree to it. Nicolas was born in Rome, and it made sense for him to know something about the great art that was also born in the city. I wanted him to see it before his experience of it could be compromised by his understanding of its reputation. We invited his friend Luca along to make it more interesting. Luca's mother hadn't seen it in years,

and she decided to come as well. I promised gelato when it was all over.

I had been visiting the Sistine Chapel at this point for a year alone without telling anyone what I was up to. I didn't really know myself why I kept returning. One visit I could justify, since it was long overdue for someone who lives in Rome. But to return again and again requires an explanation, which I couldn't supply. Each time I would leave Vatican City feeling either irritable and confused or slightly excited by something I managed to notice. Each time I thought was my last until within a few weeks I would be looking at my calendar to see if there was a morning I could set aside for another visit. I felt drawn to it even while dreading the crowds and worrying about the time it would take out of my day. After a year, I thought it might yield itself to me in some way if I brought along other people.

Going with friends made it seem like something you might do on holiday, and it helped to lighten my approach. But it was late July, and the crowds of people who actually were on holiday moved like a swarm through the warm galleries. The boys found relief from their boredom, briefly, in the Egyptian collection, where they saw the small wax ushabti figures and statues of familiar gods they knew from contemporary adventure stories.

Still, it took forty-five minutes to shuffle our way along, following the signs for *la Cappella Sistina*. When we at last fit ourselves into the crowded room,

I looked up and felt a sense of warmth and familiarity when I saw God flying, creating, and commanding. I felt the individual pieces of the narrative connecting and, though I still felt engulfed by the ceiling as a single work of art, I also felt my previous visits and the time I had spent taking it apart for my own analysis had at last given me a way to read a part of it.

Every little thing in this fresco has meaning, and for the first time, I began to pay attention to some of the smaller details, such as Michelangelo's obvious delight in painting muscular legs. I saw the softness of the feet, of the toes, and of the ignudi, the naked sculptural figures. Suddenly, I couldn't believe all the toes Michelangelo had painted and how that made this story a tale of humanity as much as divinity.

The boys looked around the room. I told Nicolas that the important part was on the ceiling. He looked up for a few seconds and then down again. I urged him to look up, but he couldn't do it. He wasn't being defiant; he looked quite confused. His friend looked equally mystified and, if possible, even more miserable.

I tried to point out some of the parts I had found interesting. I recounted the story from Genesis by going along the panels. They conceded that they had heard that story before. I tried to help them focus on one panel, on God creating the universe, and, though they tried, they couldn't do it.

I looked at Nicolas and Luca trying to make sense of the ceiling. These boys had seen more than their share

of biblical imagery growing up in Rome. The story was not the problem. But it was obvious that they didn't know why all these people would willingly crowd into this room and stare upward. My first visit to the Sistine Chapel was irritating. All my experiences of it have been irritating in different ways. I was beginning to see that this feeling that had seemed like an obstacle was actually a part of the experience of something that is so much larger than I expected. Arriving without preconceived ideas didn't help them, I could not help them, and the audio guide for children didn't really help either. I suggested we leave and find the museum café. Nicolas looked a little saddened, as though he'd let me down. "I'm sorry," he said, as we left the room and the crowds behind us. "I don't know what to look at."

Without thinking it through, I had hoped that encountering such an exalted work as children would give them a chance to see it fresh, to see it more natur-ally than I had done, and without the weight of its fame. I didn't expect it to be a sudden revelation, but I wondered if they would have any reaction to it. But now I see there is something about this work that is like life, in the way that we are just born into the flow of time. We don't start at the beginning, and we don't have the whole picture. It is also like life in the way it can — periodically, when we change our perspective a little, shift our weight, and turn our head — suddenly appear to be so painfully beautiful, so filled with meaning, so sublime.

Seeing it amounts to struggling with all the unknowns in our world, beginning with our existence and ending with whatever happens once we no longer exist. The images tell a story that is beyond human comprehension, and they can only gesture toward meaning. Finding its meaning for ourselves is something we learn to do. The ceiling frescoes were made at a distinct time, painted between 1508 and 1512 at the height of the Italian Renaissance, when Leonardo da Vinci was still alive and Raphael was painting just down the hall, when Pope Julius II believed that art was great and could both project and inspire greatness, and before a mercenary, starving army marched into Rome along with some of the followers of Luther, slashing, burning, and murdering their way through the city in a burst of militant fury mixed with nascent, raging Protestantism and hatred for everything such a voluptuous work of art represented to them. This ceiling was painted before coverings were applied to hide nudity in paintings and on statues and before the Roman Inquisition burned a philosopher in a public square. The Sistine Chapel comes from a world before us with our twenty-first-century preoccupations, where we don't really believe that art can do anything to us, but we come to see it anyway, just in case.

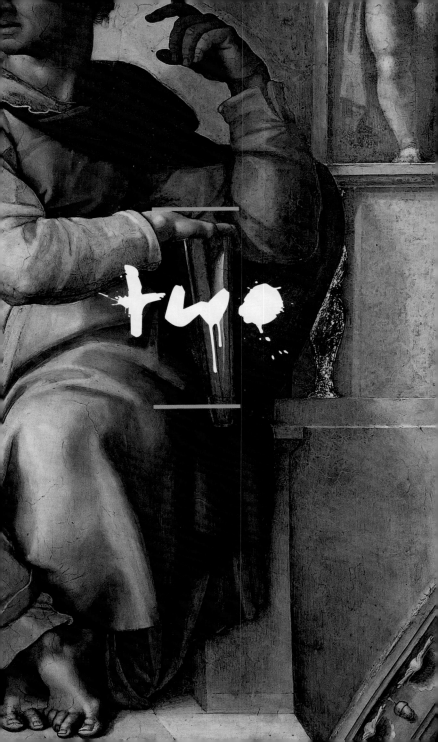

THE SIBYLS AND PROPHETS

Visionary Art and What It Costs

Whenever I enter the Sistine Chapel, I look along the middle part of the ceiling. My eye is drawn to the central panels because they are all in a line and one after another. They form the most linear narrative in the whole fresco. "In the beginning God created the heaven and the earth. And the earth was without form, and void; and darkness was upon the face of the deep." In the beginning seems like a good place to start.

As the images in that central narrative became more familiar, I started to find that those surrounding it became more interesting. That's when I really started to see the enormous sibyls — the pagan female prophets who appear in Virgil's *Aeneid* and Saint Augustine's *City of God* — who, along with the male Hebrew prophets of the New Testament, are human but connect to the divine to bring messages to humanity.

The sibyls appear in the writings of early Christians such as Lactantius, who lived in the third century and was an advisor of the emperor Constantine the Great. Lactantius and other writers of his time saw a link between the prophecies of the sibyls and the coming of Christ, which they used to convince people to convert to Christianity.

Sibyls are well represented in the art of the Italian Renaissance. Raphael painted them in Rome on the walls of the small church Santa Maria della Pace, and Filippino Lippi painted the Cumaean Sibyl in nearby Santa Maria sopra Minerva. Pinturicchio painted four of them in a chapel in Spello, Umbria. Later, in the seventeenth century, the Bolognese painter Domenichino painted the Cumaean Sibyl holding a scroll showing some slightly obscured Greek text. Rome's Capitoline Museums, where the painting is now housed, translates the text in Italian as "C'è un solo Dio infinito e non generato" ("There is only one God infinite and unborn").

Lactantius quoted the pre-Christian Roman scholar Varro, who listed ten sibyls, though Varro's original text is now lost. Michelangelo painted five sibyls. He placed three, the Libyan, the Cumaean, and the Delphic Sibyls, on one side of the ceiling, and the Persian and Erythraean Sibyls on the other. His reasons for choosing these five are unknown. They are huge and quite masculine looking, which might be meant to signify their power or could simply be the result of Michelangelo having used male models.

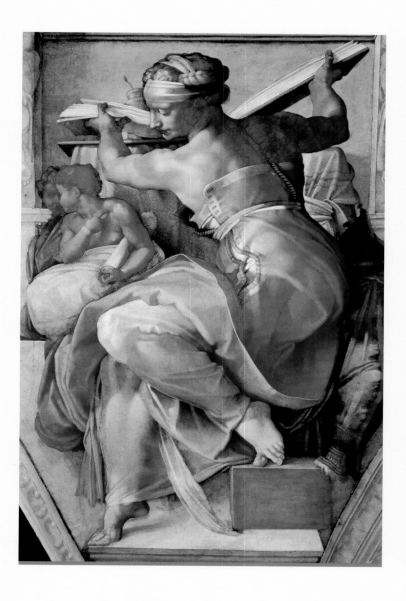

I spent some time one morning looking at the Libyan Sibyl in her strapless dress, orange layered over white, trimmed in lavender, and with a decorative cord that lines up with her spine in a way that makes the dress seem like part of her body. She is seated but has twisted away from the viewer to pick up a large open book of prophecy and is looking back over her left shoulder. Most of the commentary on this portrayal of the Libyan Sibyl describes her as having uttered her prophecy and being in the act of closing her book. But to me she looks like she's only just getting started. She's fetching that book and is about to swing around and tell us what it says.

Michelangelo placed these giant seers at the points where the ceiling curves, encircling the central story of the creation, the fall of man, and the flood. Here, they are almost architectural in their size and muscularity, and it is these mysterious, otherworldly, ancient, and (in his depiction) ambiguously gendered beings that support the central biblical story of the origins of humanity, of the lofty beginnings and the humiliating fall.

They strike me as representing artists who, like the sibyls and prophets, are human and yet connect to an unseen source to bring us cryptic messages. Their prophecies are often ambiguous, difficult to discern, and subject to interpretation. Sibyls prophesied that a child would be born who would bring prosperity to the world, which sounds like the coming of Christ. The Libyan Sibyl told of the Lord bringing light to the darkness. The sibyls with their books of prophecy suggest that the knowledge

that Christ was coming already existed within the sibyls themselves and, therefore, within the pagan world. But, with their ancient lineage and visions of the future, they also convey a secular message of the accumulation of time, of lost knowledge, of all the things we're unaware of that continue to affect us. They physically support the story of the creation of man, they hint at the coming of Christ, and then as beings of the pagan world, it seemed to me that they undermined the whole Christian story, but Michelangelo would have seen them as a part of it.

At the time that Michelangelo was painting the ceiling, there were Catholic scholars working on intricate humanist philosophies of religion. There was Giles of Viterbo, an Augustinian theologian who might have assisted Michelangelo with the framework of the ceiling. He was known for using Plato and the Hebrew mystic trad- itions of Kabbalah to illuminate Christian theology. Giles found what he saw as Christian truths beyond and before Christianity, and he wanted to bring forward what was good in the pre-Christian world. He thought that Christ's divine communication was too much, too dense and rich for us to grasp all at once, and that we needed artistry to mediate it. Over time, he thought, humans would gradually increase their understanding and would see that all the ancient religions were part of the divine plan that would lead toward enlightenment; we would have to know the past if we were ever to reach such a point. Both Michelangelo and Raphael were influenced by Giles, who was a part of the pope's inner circle during their time.

Giles of Viterbo was given the task of church reform in the early sixteenth century, but the main scholar of his work, John W. O'Malley, laments his tendency to work from intuition rather than "in ordered analysis and systematic construction of argument." Giles addressed the Fifth Lateran Council in 1512 by telling the assembled church fathers that "Men must be changed by religion, not religion by men." Although this statement is usually described as conservative because it presents religion as fixed and constant and humans as wavering and unsure but striving toward it, still there is humility in his idea that we should approach the myths and allegories of the pagan world with a kind of intellectual and emotional openness. These stories were not there to be used by the men of religion, but to be received. We needed to approach them as we would a piece of art, to make an effort to understand them, to allow these stories from the pagan world to enrich our experience of Catholicism, not to change it.

In reading about Giles now, I can see that he believed that Christianity would prove to be the ultimate religion for the world. He was not advocating for tolerance of different points of view on religious matters. What I find interesting about him is his belief that art is a means of delivering other kinds of knowledge, and that a response to the artistry in prophecy and in scripture has a place. His religious vision was expansive, artful, and intellectually challenging.

At the same time, Dutch scholar Desiderius Erasmus, another Augustinian, was working on his annotated text of the Vulgate Bible to correct errors that were made as the text was copied, and also to correct the errors of translation from Hebrew into Latin made by Saint Jerome on the cusp of the fifth century. There was great freedom during this period of the Renaissance, and a sense of looking to the past with fresh eyes in order to reveal the present and prepare for the future. Michelangelo embodied that spirit and approached his own work with the intention of creating images that had never been seen before. His mingling of the pagan sibyls with the Hebrew prophets and the story of Christ was entirely of its time.

The seven Hebrew prophets that Michelangelo chose to include — Jeremiah, Jonah, Isaiah, Zechariah, Daniel, Joel, and Ezekiel — appear more brooding than the sibyls, more worried or confused by their own visions. Jeremiah's chin rests heavily in his hand as he looks down. Daniel twists awkwardly to write something, a worried crease pushing up over the bridge of his nose. Andrew Graham Dixon notes that the prophets are represented as thinkers designed to show the gifts and burdens of their prophecies. "They do not comment on the story of God's plan for mankind but struggle, within themselves, to understand it."

Michelangelo painted God creating the world in the same position that the artist himself had to adopt to paint the ceiling, therefore drawing a connection

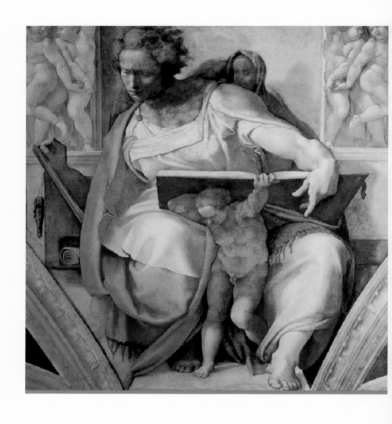

between the divine and himself. Similarly, he made his
sibyls and prophets — the beings who can connect to
something beyond our ordinary, human perception —
the largest figures on the Sistine Chapel ceiling. I see
these figures as the visionaries, as artists, who struggle
with how to express the meaning of what they see

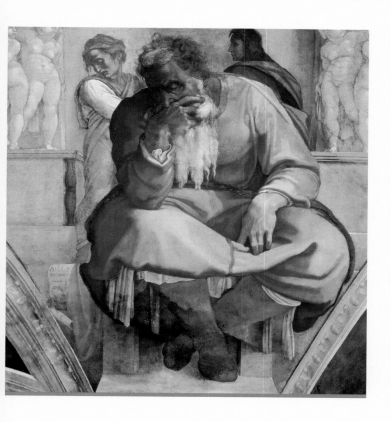

inside their own heads when it is too complex to be
expressed simply or to be understood directly. Giles
and other humanists of his time believed that humans
are too primitive to understand what God wants
to tell us and that His message can only reach us
through artistry.

IF THE ARTIST HAS THE JOB of conveying a message, the rest of us must be charged with receiving it. But how do we even recognize it when so much about art is not obvious? Looking at a painting or reading a complex text presents us with the difficulty of figuring out what the artist is trying to say, which is compounded by the fact that they can't just explain it, and they might not understand it fully themselves. The visual artist Gerhard Richter once said that the paintings of his that he doesn't really like are the ones that he understands.

Looking at art can be like reading a poem, in which sound and rhythm play a part as well as the words and their meanings and even how the words look on the page. There is a structural element, there is intention and idea, and then there is the impression, the feelings it evokes. It can feel like remembering something you already know but can't quite bring to the surface.

Sometimes I've imagined that the artist is on one side of the artwork, calling and waving, and I am on the other side — each of us without a clear view, but each of us picking up on something, some common element.

It gives me some comfort to hear artists who admit that the piece of art they produce is often quite different from their original conception of it. It might begin with a vague idea or a feeling, but as the artwork itself comes to life, the artist must wrestle with it or try to charm it like a snake.

I have to remind myself that no one invented art, and therefore it doesn't have rules. The history of art at

times seems like a quest to reproduce reality, to reach
the next technical breakthrough, rather like Masaccio,
Brunelleschi, and Donatello using linear perspective
to make their art seem more realistic; then new artists
incorporate those techniques and move onward,
changing art as they go. So many artists try to show us
a reality that isn't necessarily like the physical reality
in which we live. I think of that when looking at the
sibyls and prophets, who are big and muscular in
ways that don't conform to the physical dimensions
of real people. Their size and their separateness are
what elevate the pictures on the ceiling and take the
whole work beyond the narrative of the central panels.
They complicate the story, too, hinting at spiritual
ideas outside the realm of ordinary human life, at a
long and complex past that we can only partly know,
and projecting their prophecies into a future that
they could only have imagined. The Libyan Sibyl sits
nearest *The Last Judgement* on the altar wall and faces
toward it. Even though it was painted much later, and
Michelangelo wouldn't have known he would return
some thirty years later to work on it, it's hard not to
feel now like she's looking toward it, as a reminder that
judgement is coming.

No one invented art; and no one invented language,
and yet we humans use it and bend it and twist it
and change it to meet our needs. In trying to explain
the Sistine Chapel frescoes to myself in words, I am
translating one form of communication to another.

And this process makes it apparent that visual art is a way of communicating the things that words alone cannot convey. Language is a way of trying to get the thoughts in my head out and into other heads. It's always an approximation. And sometimes the most effective language is the least direct, such as when we use poetry to convey complex emotions, when we use a language that pushes us to feel more than to reason, and allow that feeling to open into something meaningful.

I'm trying to allow myself to experience the Sistine Chapel in a way that isn't entirely verbal, to learn the names of the prophets and the sibyls, to note their faces, bodies, gestures, and clothes, but also to stop when something about them catches my eye for no obvious reason, such as when I found myself lingering over the portrayal of Isaiah. I thought at first that it was the look on his face of a man formulating a thought that made me stop, but now I think it's that he has stuck his finger into his book, holding his place in a way that is ordinary and unremarkable, a practical action that any of us would take when we interrupt our reading to think. I know that gesture because I do it myself all the time when I'm reading and writing. I'm trying to hold on to my place and to whatever the line is that sparked the thought while I try to work it out in my head. This is creativity in action, the inner and unseen process represented in a slight bodily action.

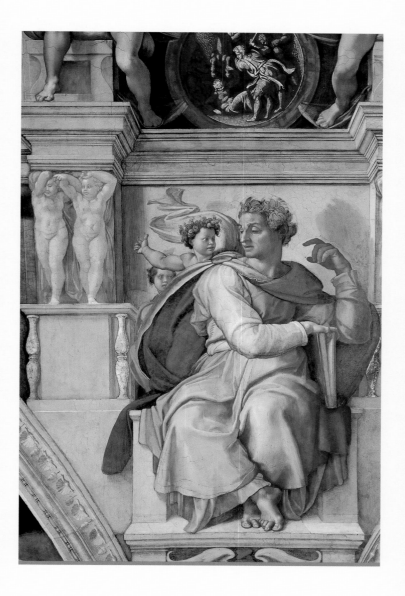

I DIDN'T COME TO ART directly as a child. When trying to remember my earliest experiences of art or thoughts about it, I inevitably come back to an innocuous moment in my teens.

I was perhaps fourteen or fifteen years old. I was standing at the top of the escalator at the Sheppard subway station in Toronto, waiting for a bus, which was routine enough that I could just look around and let my thoughts wander. For a few seconds, I watched a woman walking past, striding along outside the station, her wide pants moving like sails with her strong steps, her curly hair bouncing to match her stride, and each step matched the ka-thunk, ka-thunk, ka-thunk of the escalator in the station in a rhythm that I could both hear and feel through the ledge I was leaning on. She seemed suddenly to stand out from her surroundings, more vivid than everything around her. The experience of watching and feeling seemed momentous and enormous, but all that was happening was that a woman walked in step with the sound of an escalator that she couldn't hear. The two things were unrelated, but they came together in me. Only I could see her and hear it. It was a performance the world created just for me, and in observing it I became a part of it. I dissolved into it, and for a few seconds it was as though I was connected to everything around me in the way a tree is connected to the ground it grows in.

Then she was gone, and the escalator continued its noisy and ceaseless rotation and my bus arrived.

I didn't talk about this experience at the time because

I didn't know how to explain it in a way that could harness the whole thing. And yet, this experience made me want to be a writer. As a bookish teenager I wanted to find a way to use words to reproduce the feeling and not just the narrative. I wanted to write something that could make another person feel themselves in the world like I had in that moment. I am always trying to locate that feeling, to find it in all its small iterations, and to use words to invoke it and to pass something of my perception of it to someone else. To connect with another person through art feels like an acknowledgement, a gesture toward our shared humanity.

I recognized the essence of that sensation again a few years later, toward the end of high school, at that age when the world seems to open up and show itself in such surprising ways, when I read this poem:

> *so much depends*
> *upon*
>
> *a red wheel*
> *barrow*
>
> *glazed with rain*
> *water*
>
> *beside the white*
> *chickens*

William Carlos Williams's words seemed somehow related to my woman with an escalator. Something in them seemed of a kind with my own experience. His poem gave legitimacy to that experience.

Something about the poem felt like knowledge, but not exactly understanding. It was more like a common source of feeling or a shared truth, though what those feelings might mean was unclear and elusive. It was a surprise to see something so ordinary as chickens and a wheelbarrow turned into art, and a surprise that art could be found in the ordinary, in everyday experiences. I didn't know what to think at the time. I remember my classmates discussing the poem while I stayed silent. I had no idea how to talk about such a thing. Everything they said seemed to distance us from those few words on the page. Those words seemed like enough. The feelings evoked by the poem tumbled over me, and I felt a mutual sense of recognition. It was as if the poem and I were saying yes to each other, "yes, I know what you mean."

And though I carried on with the ordinary business of life in the years after that, of studying, earning money, and paying rent, I felt drawn to art and literature as a way of pursuing this sense of communion with the world. As I grew into adulthood, I went to galleries, I listened to music, I read books, and I tried to pay attention to whatever that thing was that seemed to catch the light at the edge of perception.

Most people have likely felt something similar, a moment when everything looks right and different, meaningful and connected in a way that makes no logical sense. But what do we do with such an experience?

These moments feel something like Marcel Duchamp's "inframince" projects that were meant to categorize

very small, insignificant things — like the difference in
the weight of a clean shirt and one that has been worn,
or the energy required to produce a giggle — but that
made you slow down and think.

They're ephemeral and quickly vanishing sensations.

IN THE SISTINE CHAPEL, it's the sibyls and prophets
telling their veiled stories and making their cryptic
pronouncements that represent the function of artists.
I don't know if it was Michelangelo's intention, but I
read them this way. They surround the central panels,
the fundamental stories of the whole ceiling, and they
represent the struggle to know what can't be known.

This puzzling seems like something we do on some
level all the time, as we churn away inside trying to
make sense of the world while we walk to the bus stop,
do our jobs, make our dinner, and tuck our children into
bed. Looking at art gives us a way to acknowledge that
we have questions, and if art does not exactly provide
answers, at least it gives us a way to recognize what we
submerge as we go about our daily lives.

Part of the fascination many of us have with cave art
is that it shows that thinking in artful ways has a long
history. We can't imagine people more different from us.
Who could possibly be more alien and other? And yet the
image of a wild pig and the handprints that accompany it
that were found in Indonesia dating from forty thousand
years ago suggest a complex kind of thinking that we
can relate to. These are among the earliest expressions

of imagination and symbolism that we know about, of a mind that could think about the past and the future and could represent something it had seen from memory. These images were made by people who thought about their lives beyond survival.

Yet there are days and weeks when I don't think about life much beyond survival. There's work and chores, shopping and cooking, tending to myself and my family. It is not as though there is no pleasure in these everyday tasks but the effort involved in keeping life ticking along easily crowds out more conscious contemplation in my own secular world.

Most of us go about our daily activities dealing only with what's right in front of us. But there are occasions when something else gets through — a piece of music, a line of poetry, a painting, the afternoon light on the tree outside the window — and we see everything differently and feel something radiant and unexpected spread through our nervous systems. All the moving parts of our daily lives stop for a few seconds, and we feel as Rainer Maria Rilke must have felt when he wrote "The Archaic Torso of Apollo" after looking at a fragment of classical sculpture. His last line is "You must change your life," as though the sculpture were addressing him as he addresses the reader of his poem.

Is seeing what we're doing in those moments? Is looking the right term? "Seeing comes before words," wrote John Berger in *Ways of Seeing*. "The child looks and recognizes before it can speak." He doesn't say

that the child "understands," and that seems crucial to thinking about my own perceptions of art. It's *recognition* that marks the starting point where meaning takes shape. There is something of me in the things I've seen around me, something of me in the sibyls and prophets, in Noah, in the soon-dead woman on the shore, in Eve, in Adam, and even in God. Something in me keeps the same beat as an unknown woman walking in time to an unheard escalator.

Maybe the idea of art being a commodity among many others is one reason why we don't expect it to do more than shock us, entertain us, or, at most, instruct us. We don't invest it with the power to shape our souls. During that period of the Italian Renaissance, the fifteenth and sixteenth centuries, Christianity was as pervasive as air. Religion was not a choice in the Europe of that time, and it governed all aspects of life. Catholic rituals shaped a person's day, shaped the calendar by which one lived with saints' days to be celebrated, with fasts and feasts, and with soul-stirring music and painting and sculpture in the places of worship. The art of that time supported the spiritual; it augmented scripture, it illustrated the stories. To look carefully at art deepens our relationship with the world in which we live.

Now, we live in the culture of capitalism. Though it's an ideology and not a religion, it governs our lives in the same way that Christianity governed the lives of sixteenth-century Europeans. It dictates what is valuable, and the contemporary measure of value is money.

Still, I think in our age we carry some expectation that art is bigger than we are, that it reflects on nations and cultures, and that it says something about us and to us, which is why so many countries offer public funding for arts institutions. It's why some nations have a poet laureate, an acknowledgement that the artist can move people, stir them in a way with language that is different from what a politician can do with words.

Now we mostly see art as something that ought to have economic value. The artist is an entrepreneur churning out products for sale, or an entertainer providing spectacle for hire. Realistically, it's impossible to separate art from money because the person creating the art needs money to live. Art costs money to create. It always has. And this has always been problematic. When Michelangelo was painting the Sistine Chapel ceiling, he wrote to his father complaining that he was working very hard and yet he had no money for rent. He might have been working for the glory of his god, but he still had to chase after his pope to get paid.

In our time, art is often viewed as entertainment. That's likely why we think we should like it, that its purpose is to amuse us, and that's why we think it should be commercial and self-supporting. We have a capitalistic view of art, we see it mainly as a commodity on the market, and that view is bolstered every time a rich man buys a painting for a sum that could substantially diminish world hunger: Van Gogh's *Laboureur dans un champ* was sold in 2017 for US $81.3 million by the estate

of a billionaire couple in the United States to another billionaire in Asia. Picasso's *Les femmes d'Alger (Version "O")* sold in 2015 for US $179.4 million. In 2022, one of René Magritte's Empire of Light paintings (he made seventeen variations on the theme of night and day) sold for US $79.7 million. In announcing the sale, the *New York Times* quoted art advisor Melanie Clore: "Over the years, there have been numerous versions that have been sold, and they have performed extremely well." She's not talking about the meaning of the painting.

I can understand wanting to live with great art, but to spend that much money to own it is more about a display of wealth than it is about the object itself. While the pope was pointing to the wealth and power of the Church, the contemporary art market points to the wealth and power of the individual.

The art critic Robert Hughes saw the rise of the art market in the 1970s as unforeseen and ultimately detrimental to the art being produced in its wake. The market, he said, "gutted" artworks of their meaning. "The price of a work of art now became part of its function. It redefined the work — whose new task was simply to sit on the wall and get more expensive. By the end of the 1970s, we were getting to the point where everything that could be regarded, however distantly, as a work of art was primarily esteemed not for its ability to communicate meaning, or its use as historical evidence, or its power to generate aesthetic pleasure, but for its convertibility into cash."

The money a painting or sculpture can fetch gives us an easy way to judge art. In news articles about the sale of paintings, it is the price that is the story. And of course such astronomical figures are newsworthy, but they tend to distort our sense of a work's true value. It's not uncommon to visit public art galleries now and hear disgruntled comments about the price the gallery paid for a work rather than what the artist might be trying to say in the piece itself. Hughes argued that it had become impossible to spend time in a museum without thinking about what the art might cost. He claimed that in the 1950s the price of art and our experience of it were unrelated. "Price and value were completely distinct questions; the latter interesting, the former not."

Treating art as entertainment, or even as decoration, means that we approach it expecting it to please us, and yet pleasure is the most irrelevant feeling to connect with art. There's a self-help notion associated with art appreciation, a promise of moral improvement. It's possible that such an idea originates with religious art, which was meant to be didactic, but even then, the subject matter often dealt with the meaning and purpose of our lives and our fears of eternity. When I think of the way I've experienced the Sistine Chapel frescoes, I know that liking them has very little to do with it. It's more the way that looking at the images and visiting the room has opened a passageway in my brain.

Looking at these frescoes doesn't solve my problems, but it does sometimes make me feel that my thoughts and

concerns might not be so unlike those of other people. It provides some deepening sense of my own experience in the world and a slight sense that being alive isn't trivial. It leads me to think that I'm not alone, that I'm puzzling this out along with the people around me and in the way of people who lived a long time before me.

It's this elusive quality of the experience that makes trying to explain the worth of a work of art in terms other than money so difficult. Certainly, artists in reaction to the market have tried to create art that can't be bought, such as performance art, to reassert the role of meaning. But even this has sometimes moved art toward the abstract, making contemporary art more elusive, which is the opposite of the way that Catholic art functioned in the Renaissance.

Thinking of art primarily in terms of its monetary value crowds out other questions we might have about the artwork and makes it less likely that we will find anything meaningful within it. We can argue that Van Gogh, whose paintings now are wrapped in fortunes, was trying to see his inner life and portray it with colour and texture, as he wrote to his brother Theo in 1888: "I want to paint men and women with that something of the eternal which the halo used to symbolize, and which we seek to confer by the actual radiance and vibration of our colourings.... Ah! portraiture, portraiture with the thought, the soul of the model in it, that is what I think must come."

It's easy to lose sight of what the artist is trying to show us and even easier to be dazzled by the price tag.

ON THE BUS ONE VERY WARM DAY in Rome, a man got
on clutching a well-thumbed copy of the New Testament.
He stood in the centre of the crowd, blocking the exit
doors, and told us that we had to listen to him. What
he had to say was so important, he told us, and it's all
contained in this book. He was fervid and yet lucid,
and utterly convinced of the importance of the book.
Vi prego, he kept saying, I beg you. I beg you to give this
your full attention. Your souls are in danger, he said.
Vi prego. A woman sitting in the seat nearest him fanned
herself vigorously and looked out the window, some
of those on their feet tried to push toward the doors at
the back. Everyone looked away, embarrassed for him
to be speaking so plainly and loudly about our souls.
I happened to be standing directly across from him,
and when he looked at me, I didn't know what else to do,
so I looked back. It's not that I disagree, I thought as I
looked at his desperate face, it's just that I feel this way
about art. Look! You need to see this. I beg you to look.
Vi prego!

For a person who has the means to spend millions
on a painting, it must give them a huge rush, a shot of
adrenaline straight to the ego. To own a Van Gogh might
make a person feel as though they have siphoned off
some of the power of Van Gogh himself. And certainly
during the Renaissance the wealthy wanted to own the
paintings and sculptures of powerful artists for the same
reason. Pope Julius II understood this, and it is why he
went to extraordinary lengths to pay for the art and

architecture that would bring glory to the Church and ensure his legacy. But such glory seems secondary; that's only the peripheral strength of the art, while its real potency is available to anyone who will just look at it.

When a person is moved by a painting or a piece of sculpture, the experience does not involve the ego but whatever is its opposite. It cuts through the noise about the price of the artwork, about our deadlines and work obligations, about paying the bills and washing the dishes; it cuts through what I might think of myself and what others might think of me, and it leaves me alone to grasp at and reach toward a thought I can't quite hold on to but that feels both crucial and also like nothing more than a curtain in an open window rustling in a light breeze.

IN THE TRASTEVERE NEIGHBOURHOOD in Rome, there is a museum that was once the villa of a wealthy Renaissance era man. The Villa Farnesina, as it is now known, belonged to Agostino Chigi, a banker to Pope Julius II and one of the wealthiest men in the city during the early sixteenth century. It is in the banker's home that the world of money and art collide with such force that we're still feeling the effect. Chigi made himself indispensable to Pope Julius II's scheme to return Rome to its former glory, to make it even better than Ancient Rome. He continued his work with Pope Leo X after Julius died in 1513. It was Chigi who came up with the idea of creating a special indulgence that would pay for the rebuilding of Saint Peter's Basilica.

Indulgences have a long history in Catholicism. A Christian who made a pilgrimage to Rome would be granted an indulgence, which counted, like a points system, in their favour against their sins. Pilgrims who climbed the twenty-eight Holy Stairs, brought to Rome in the fourth century and said to have been the marble stairs that Jesus climbed in Jerusalem on the way to his trial, could also expect a certain leniency. During the Renaissance, pilgrims were told that climbing the entire staircase on their knees and reciting the Our Father on each step could reduce the time their soul would spend in purgatory by as many as nine years per step.

But it wasn't easy for Christians in other parts of Europe to go to Rome; and praying a soul out of purgatory was an onerous and lengthy undertaking. So, for those willing to spend a little money, there were indulgences that allowed a Christian to buy forgiveness from sin. There was even a sliding scale based on means, where a nobleman would pay the most to buy an indulgence and a peasant the least.

All that beauty being expressed in the form of architecture, sculpture, and painting, all those gorgeous churches, all of it cost money. Never mind that it was done to glorify God, the money had to come from somewhere here on earth.

Indulgences were considered a legitimate form of penance. When Christians confessed their sins, they were asked to perform a task, or do something good for their community, and so it was acceptable to contribute money

toward a good Christian cause as penance in the form of an indulgence.

But in the early sixteenth century, friars were going through markets in Northern Europe offering to sell God's forgiveness, which was a corruption of the practice. They would send the money south to Rome, minus their own sales commission, to pay for the art and architecture that these poor Christians from another land would never even see.

The Church was quite happy to promote and sell an indulgence for your sins and one for your dead relatives too; one that was guaranteed to help them bypass purgatory altogether and without the need for prayer. The official justification was that the saints and the Virgin Mary had created a glut of goodness in heaven, and this could be divided up and doled out to ordinary sinners for a price. The indulgence to raise money for rebuilding Saint Peter's also promised to do good for future Christians, since the money was being used to rebuild the spiritual centre of Christianity.

Obviously, such an outrageous scheme had its critics. Early in 1517, when Johann Tetzel, a famous Dominican friar and indulgence merchant, was working his trade and selling the Saint Peter's Basilica indulgence, Martin Luther, an Augustinian friar and professor of moral theology in Wittenberg, Germany, began hearing from his parishioners that they did not need to pray or to listen to his sermons because they had bought an express ticket to paradise. Luther used his pulpit to preach

against the practice, and in response Tetzel threatened to have him burned at the stake as a heretic. By late October of 1517, Luther, dismayed that Christians seemed to believe that indulgences made them free to commit whatever sins they pleased, produced his *Ninety-five Theses*, also known as the *Disputation on the Power of Indulgences*.

He sent his *Theses* and a letter to the Archbishop of Mainz to make him aware of the abuse. Not only did the archbishop know about the issue, he was receiving a percentage of the sales. The archbishop sent Luther's letter to Rome but didn't hear back until the summer of 1518.

By then, Luther was already becoming famous. His *Ninety-five Theses* were printed and distributed in cities around Europe. His critics complained that he was airing theological disputes in public, though they took comfort in the fact that he was airing them in Latin, which laypeople couldn't read. As a result, Luther began responding to his critics in German, which expanded his popularity at home. His influence grew as he preached locally and published his thoughts for a wider audience.

By spring of 1518, Luther was refining his ideas in public about the inner struggling, striving, and wrestling against our sinful human nature, which he thought should be at the centre of Christian life. This was meant to be difficult, and there ought not to be shortcuts.

Pope Leo X refused to listen to Martin Luther's concerns when he first heard of them. You have to wonder what the world might be like now if Leo had only said, yes, perhaps you have a point.

Considering all the violence and upheaval that would ensue, Luther's 1517 *Theses* were quite mild. He still accepted the pope's authority, he still believed that indulgences could be used with care, he still believed in purgatory, and at that point he also believed that prayer, repentance, and good works were the way out of it. Luther wanted the pope to know that raising money this way to rebuild the glorious Basilica of Saint Peter in Rome and to create the exceptional art of the Renaissance was putting the souls of ordinary Christians in danger. It wasn't the obvious tax grab that bothered Luther (though his criticism of greedy churchmen was part of his public appeal) as much as it was the perversion of the understanding of how a soul reaches heaven. This practice was depriving honest Christians of an opportunity to look deeply within themselves and face their sins. Leo X's official theologian responded to Luther's original *Theses* with a dismissal, noting that anyone who said that the Church could not do what it was doing with indulgences was a heretic.

The more critics complained of his audacity and his heretical challenge to the pope, the more Luther refined his arguments. The official response rested on the authority of the pope over scripture, which was exactly the point that Luther believed was mistaken. Only scripture could tell us what was right, not the pope.

The Church gave him sixty days to appear in Rome, where he could repent, but officials in Wittenberg decided

to protect him. Instead, the pope sent a representative, a Dominican theologian known as Cajetan, to meet Luther in Augsburg. Cajetan was given the authority to urge Luther to recant, and to excommunicate him if he would not. Cajetan tried to persuade Luther to apologize for his errors, but Luther refused to concede. He used his discussions with the pope's representative to hone his own understanding of the central position of faith in Christianity, which differed from the Catholic system of doing penance for sins and being forgiven. He refused to apologize because he did not believe that he had mis-interpreted scripture.

Instead of excommunicating him, Cajetan sent Luther's explanations to Rome. While waiting for a response, Luther's supporters smuggled him out of Augsburg and back to Wittenberg where he wrote and preached about this pope who was placing himself above God's law.

Luther's popularity became problematic for Leo X, who continued to send representatives to talk to Luther's political supporters and to Luther himself to pressure him to recant. At the same time, the pope was dealing with other pressing political issues — a campaign against the Ottoman Turks, the need to elect a new Holy Roman Emperor — and Luther continued to deliver and publish his sermons, to study the history of canon law, and to debate his critics.

By 1519 his reputation had spread among Christian humanists in Europe and among his fellow Augustinians. Luther was also popular among lay people.

By 1520 he had studied the works of previous "heretics" such as Jan Hus and Lorenzo Valla and found the Church to be wrong in its position against them. The Church responded to this, and his ceaseless writings, with a papal bull comparing Luther to a wild boar loose in the vineyard. He was again given sixty days to recant. Luther used the time to write and to preach. He urged the new Holy Roman Emperor, Charles V, to defend Christianity against the papacy, and he urged all Christians to see themselves as defenders of true Christianity. They had a duty to judge the Church in Rome and to act, he said.

Luther's popularity was greater than ever, and ordinary Christians felt part of the struggle against an oppressive church.

Finally, Luther wrote to the pope laying out his grievances against the Church and, though he tried to be conciliatory to Leo as a human being, he explained his understanding of faith and pointed to the ways in which the Roman church was corrupting it. Leo denounced Luther and threatened him with excommunication. Luther then called the pope the Antichrist, and by early 1521, Luther was finally declared a heretic.

Luther came to believe that the popes incorrectly saw their authority as being greater than the authority of scripture. He believed that scripture should not be interpreted within the Church's tradition and subject to papal authority because scripture is God's word and

is its own authority. It is his insistence on scripture as the only authority that set him apart from previous dissenters.

Sola scriptura became his mantra. But, as more people went looking for the true meaning of Christianity directly in scripture, they also interpreted it differently. Luther believed that those who read it would interpret it as he had done. Instead, differing interpretations divided people into sects, and, as a result, the wars of religion began in the 1520s with reform-minded Christians fighting and killing each other over their diverging understandings of scripture, while also being united in their hatred for Rome.

A piece of that hatred has been preserved and is on display inside the house of the papal banker. I knew none of this when I wandered in one morning to have a look at Raphael's fresco *The Triumph of Galatea*. I was walking by what had been Chigi's villa, which sits behind a gate and just off a road that runs parallel to the Tiber river, and decided on a whim to go inside.

The walls are covered with secular imagery painted by some of the well-known artists of the Renaissance, including Sebastiano del Piombo and Raphael. Chigi intended to live there with his mistress, who would become his wife, so he had the artists decorate the villa with paintings about classical antiquity and love. He was a wealthy man displaying his financial power — power that he had attained through the Church, and through indulgences — with the art on his walls.

It wasn't until I walked upstairs to see the Room of Views, showing scenes of Trastevere rooftops and trees, that I saw evidence of the clash. On a side wall there is a fresco of the ceramic-tiled roofs and the bell towers of this Roman neighbourhood. It's a serene picture except that it's marred by graffiti scratched into the paint, right into the sky. The soldiers who sacked Rome in 1527 scrawled a message into the plaster. They intended to ruin the fresco, with the same rage that had made a man damage Barnett Newman's painting in Berlin hundreds of years later. The soldiers were a mixed bunch, including the German Landsknechts who were influenced by Martin Luther. They were angry about the decadence of the Church and reviled the opulence, the beauty of Rome and all its refinements. The frescoes in Chigi's villa were an affront to them. They were hungry, they hadn't been paid in quite some time, and they were enraged by all the signs of Rome's excess. And they had come to agree with Luther that Satan was at work in the papacy. The translation of the German graffiti reads "Why should I who write not laugh — the Landsknechts have set the pope on the run." The almost five-hundred-year-old fury is palpable.

Michelangelo finished the Sistine Chapel ceiling in 1512 while the money to pay for such art was plentiful. He was a devout Catholic artist focused on creating frescoes that would convey a spiritual message but also impress upon the viewer the greatness of the Christian concept of God and by extension the greatness of God's

representative, the pope in Rome. That pope, Julius II, was also known as the Warrior Pope because of the battles he led personally and the territories he seized to fund his plans for Rome. The expanded use of indulgences worked to bring in the money necessary to realize the pope's vision. But the myopia of the powerful in Rome in the years following Julius, their certainty that they had a right to take what they needed to rebuild this great city, to demonstrate the dominance of Christianity, meant that they didn't see the growing resentment outside of Rome and the threat of a backlash. They didn't take Luther seriously enough.

The Sistine Chapel ceiling is a monument to a vision of art and spirituality together. It came into the world just before the Reformation changed Christianity, and it tells the story of Christianity as it was understood at that time. It shows creation and destruction, life, death, and sin, mixed in with mystery and hints of redemption and how to find it. All the Christian concerns are represented in an artistic rendering that is designed to touch the emotions as much as the intellect. But it's a vision that cost money to produce. All the work in Rome that at that time had been created to renew the city — particularly the costly construction of the new Saint Peter's Basilica — was financed through war and indulgences, essentially through violence and deception.

Whereas the Catholicism of Rome held art in high esteem, some of Luther's early followers began to hate religious imagery. In 1522, one of Luther's fellow reformers

in Wittenberg wrote a tract condemning religious art, using the Old Testament's proscription of the worship of idols as the basis of his argument against it. As a result, people ran into the churches, tore down the artwork, smashed it up, and set it on fire. Such iconoclasm, which is also motivated by a fear that the image has power, became a feature of the Reformation in the centuries that followed.

The soldiers who ransacked Rome were mercenaries from different places, but many were affected by the new Christian thought that would be known as Protestantism only a couple of years later. The Landsknechts believed they were carrying out God's will by destroying Rome. Those who had only recently been part of the Catholic laity were now in a position to destroy Catholicism. Luther himself was against this sacking, although he thought the city had it coming. His words and thoughts were understood to give licence to these Christian soldiers who killed the Swiss Guard in front of the Vatican, killed children in orphanages, the sick in the Santo Spirito hospital, and priests on the altars of their churches. They raped nuns and slaughtered the people who sought sanctuary inside the unfinished Saint Peter's, piling their corpses onto the altar.

The Landsknechts who scrawled their message on the fresco in Villa Farnesina were correct. They did have the pope on the run, Clement VII by then, who managed to make it out of the Vatican and over to the fortified Castel Sant'Angelo where he stayed for a month while this army raged around the Vatican, through the streets,

and into the homes of ordinary Romans. They looted and defiled the centre of Catholicism for several weeks, they tortured people and extracted ransoms before the pope finally negotiated a deal to pay them off.

These were early days in the religious wars, of Christians fighting each other, until finally, nearly two hundred years later there was some recognition that reconciliation was impossible. In *Rebel in the Ranks*, which historian Brad S. Gregory published to commemorate the five-hundredth anniversary of the publication of Luther's *Ninety-five Theses*, Gregory wrote that "the Reformation inadvertently made Christianity into an intractable problem." With Protestant reformers claiming that the Roman Church's teachings were wrong, and the Roman Church claiming that the reformers were heretics trying to introduce false doctrines, many people were left to question and reinterpret for themselves what Christianity was supposed to be about. Gregory points out that religion was so embedded in all aspects of society, from politics to trade and economics, that it touched on every aspect of life from the public to the personal, which is why the Reformation proved so disruptive. The only way to resolve its myriad issues was to separate religion from other parts of life, so that religion became a matter of individual choice, which is far from what the original reformers wanted when it all started. They wanted people to be better Christians and were certainly not advocating for the kind of freedoms that resulted.

"The Protestant reformers also did not intend another consequence of the Reformation that remains deeply influential today: people's ability to answer questions of meaning and morality in an open-ended variety of ways both religious and secular," writes Gregory.

The freedom to think as we please, to find meaning where we choose to look for it, which is something we take for granted, owes everything to this unresolvable conflict.

The fact that I can stand in the Sistine Chapel and look at the ceiling painted before the beginnings of the Protestant Reformation, and look at *The Last Judgement*, which Michelangelo painted after the Sack of Rome, the fact that I can look at these works and not be a Christian but still find meaning in them, all stems from this place and the violence of that time. An inadvertent outcome of all the fighting over things that cannot be known is that someone like me can choose not to believe and can even write about it without being burned at the stake as a heretic.

The Sistine Chapel ceiling is from a time before any of that. It's from the end of a particular part of the Renaissance when art was being used to explain and explore the Christian story, to embed it in the culture, and to create symbols of its dominance. Catholicism could still see itself as living up to its name as the universal and unlimited church. It's a great work of Christian humanism. From where I stand in the twenty-first century, it looks like a time of cohesion compared to

what came so soon afterwards. A time when the question of our mysterious existence could be answered by the Church, with the pope as divine interpreter, when the mystical feeling a person experienced when entering a church could be attributed to the presence of God and when art was meant to amplify all of it, to complement Christian life, which was, by definition, Catholic life.

WHEN JAMES AND I FIRST ARRIVED in Italy all those years ago, we were both overwhelmed by too much art and too much history. I could see that ancient Roman frescoes looked different from medieval Madonnas and that they were quite unlike anything painted in the Renaissance. But when was the Renaissance? Even figuring out when it began can be a headache that depends on where you are and who you consider an authority. Did it originate with Giotto? Or did he just continue what his teacher, Cimabue, started? Did it begin in the early 1300s, when Giotto painted figures from the lives of Mary and Jesus as well as the personifications of the virtues on the walls of the Cappella degli Scrovegni in Padua? But isn't Giotto still a little bit medieval? Look at those Byzantine eyes that he painted. Is it possible to distinctly separate one part of the past from another, or does the past continually feed into the future whether or not we are fully aware of all the details?

The year before we moved to Italy, when James and I were in Spain, we came to love the work of Velázquez and Goya. The art in Madrid seemed easier to see, more

earthy, and less holy. In Italy, there was too much to see. The art is almost entirely about Christianity, and I wasn't convinced at that time that I wanted to learn so much about the religious context. Its value seemed only to be that it was old and part of a historical record.

Much of the religious art reminded me of Sunday school. As a child growing up on Lake Simcoe, I would drop in on different churches. My mother allowed me to go to any denomination I liked on Sundays, except the Catholic church, for the stories and the cookies. In Rome when I saw paintings of Saint Sebastian being stuck with arrows or the angel Gabriel telling Mary that she will give birth to the son of God, I recognized them only because of those weekly Bible stories.

I didn't identify as a Christian; even as a child, when I knew no other religion, I didn't give it much thought. I had questions about my existence and life after death, like anyone, but I accepted them as mysterious and unknowable. I didn't find the Christian stories of creation and eternal life to be useful.

I wasn't looking for meaning in the paintings, frescoes, and sculptures I saw as I wandered without a plan in and out of churches and galleries in Rome and other Italian cities. Mainly, I was interested in placing them in their proper time and in understanding what they might have meant to their contemporary viewers. All I could see at first were the endless medieval Madonnas, their strange flat faces, and their overly adult looking babies. I saw the Renaissance paintings as beautiful because

they were meant to be so. They're rich and colourful and pretty, and that's all I noticed.

And then, over time and through repeated exposure, this changed. Familiarity started to have an effect and I could begin to imagine what it might have been like to live among all this devotional artwork when Christianity ruled all aspects of life, when it defined not only a person's own identity but their community and all their relationships. Christians are supposed to pray seven times a day, and in sixteenth-century Rome there were likely more people observing that rule than there are now. After living in Italy for a few years, I could see how the artwork was an aid, a reminder, a point of focus for worship. I had a sense of what it must have been like to live inside a community organized around spiritual concerns. I imagined that seeking meaning was not an unusual thing to do and was certainly not such a lonely endeavour. It wasn't something you did quietly by yourself.

In Italian cities and villages there are wall frescoes, paintings, and altars decorated with biblical stories meant to force you to think and know and consider your life within this spiritual context. The art was not separate from religion and religion was infused into the place and into the architecture, the church bells, the Madonna painted onto every street corner, even into the calendar with its constant stream of saints' days. It's hard to imagine a moment when the rituals demanded of the most ordinary Christians would not have been on their minds.

In revisiting churches and galleries and seeing the same pieces over and again, I started to recognize the themes — another Slaughter of the Innocents, another sacrifice of Isaac, another Saint Peter receiving his key to the kingdom of heaven, and of course the Annunciation with Gabriel always shown with wings sprouting from his back and telling Mary that she will be the mother of the son of God. There are so many images of Mary and the infant Christ, the solemn depictions of Christ being taken down from the cross, and then the images of his resurrection.

As I got to know the country, I saw that these stories looped around Italy in pictures and statues, and they were repeated but with a difference every time another artist took on one of the old subjects. All this cycling through the stories and coming back to the same images again and again reminds me of the constant prayer required of ordinary people and that priests, including Martin Luther, would have chanted the psalms every day. It would take two weeks to chant all 150 of them and when they were finished, they would begin again. It was a way to absorb them into yourself, to know them by heart.

Even without being religious, the effect of the repeated themes and images worked something into me over the years. I absorbed them too.

The medieval Madonnas eventually stopped looking the same to me. And by the time I saw a painting in Milan of the Madonna and Child by Ambrogio Lorenzetti

painted around 1320, I could recognize the Byzantine style in the long fingers and in Mary's eyes, and even the pose. I could see that this artist created a softer effect than some earlier renderings of the same subject. In Lorenzetti's painting the figures at the centre are rounded and less stiff, and the pattern of Mary's robe and the stripes on the blanket used to swaddle the infant come as a surprise. I wasn't judging whether the quality of the painting was better than others I'd seen; I was using this painting to think about the way that this pairing of mother and child has endured in Western culture as a symbol of love, as something that so much depends upon. Since the Messiah is born as a human child, the divine incarnate, he is vulnerable to all the bad things that can happen to human children. She is the one who must keep this story going. It's Mary who must protect, support, and nurture this child as he grows into the man who will become the world's saviour. It's such an enormous responsibility and the veneration of her in Catholic art seems justified.

All the paintings and sculptures of Mary holding her dead son after he's been taken down from the cross became more distinct to me after these years of casually looking. Her grief multiplied and left the realm of story and entered the real world where real things hurt. Christ's beaten, broken body began to seem less a subject for artists to demonstrate their skills in anatomical painting and more the very picture of human suffering. Despite my resistance to the Christian story, I felt the

conviction and concentration of these artists. I felt their sincerity and belief. Whatever it was that the artists were trying to say was starting to reveal itself to me in these moments when something in the image made me think about the biblical story and about the time it was painted until my thoughts eventually came back to the present where I stood staring at it. I could see how the artwork might have functioned in the Rome of the Renaissance. I could almost feel it.

And though the popes and their financial schemes effectively splintered Christianity instead of uniting it, though their need for money to finance the artistic revival of Rome brought violence and mayhem, despite everything that was destroyed, it is the art that endures. It's still here, waiting, quietly available to anyone who will only take the time to look.

THE
ANCESTORS

The Influence of Those

Who Came Before

In the Book of Matthew, there is a list of all the men begetting boys who become men begetting more boys and this traces the male ancestry of Christ from Abraham begetting Isaac all the way to Jacob who begat Joseph who was the husband of Mary who gave birth to Jesus. Michelangelo created a ring of these ancestors around the top part of the wall where it meets the Sistine Chapel ceiling.

They are above the frescoes that were painted by the previous generation of artists, and they link his frescoes to those that were already in place when Michelangelo began his work. He placed the ancestors, representing Christ's human lineage, directly above the older portraits of the popes, who represent his spiritual lineage within the Church. They are painted in lunettes, the semi-circular portions above the arch of each window, and in spandrels, which are the elongated triangular sections directly above the lunettes and that jut up between the prophets and sibyls.

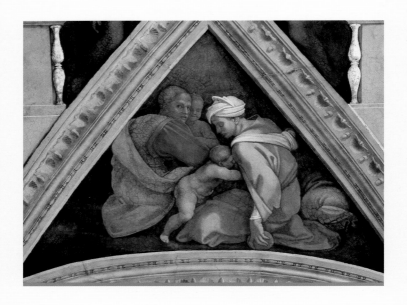

Michelangelo included the names of the forty ancestors who are listed in the Book of Matthew, but there isn't much to suggest that his painted figures correspond to these ancestors. The catalogued names are all of men, but Christ's ancestors are portrayed as women and children, too, as families, of young and old men both. Originally, there were several more ancestors painted on the altar wall, but Michelangelo destroyed them when he prepared the wall in 1535 for *The Last Judgement*.

Many historians have tried to line the figures up with the names, and others have chosen to see this gathering as representing the people of Israel who preceded Christ.

To me it seems like an acknowledgement that lineage doesn't just involve the male line and that it is women

who not only bear the children but raise them as well, and it is also an acknowledgement of the complex web of human ancestry because Abraham did not only have Isaac who begat Jacob, but seven other sons too. The ancestors are everyone who preceded Christ. Christians can feel themselves folded into the narrative, as all Christians are considered to be the descendants of Abraham, who God promised would be the father of a multitude of nations. Jews, Christians, and Muslims all draw a line back to Abraham.

On a grey January morning, I decided to make another visit to see the ancestors, especially since they are so difficult to study in reproduction. I had by this time been going to the Sistine Chapel often. My initial sense of reluctance was long gone, overwritten with new experiences and a new relationship to the place I had for so long avoided. Still there was something I couldn't quite grasp, something about the chapel itself and the vision of Renaissance Catholicism that felt personally resonant, without my entirely understanding why.

There was a steady stream of people heading into the building that morning, but not an unmanageable crowd like in warmer weather. I could take my time walking from room to room. I wandered out into one of the gardens, drawn by the dome of Saint Peter's Basilica rising above everything else, with a cluster of umbrella pines in the foreground. The sky was a thick mass of grey and the dome pewter, like a beacon in the gloomy sky, and of course it is that to Catholics, but to me it's a

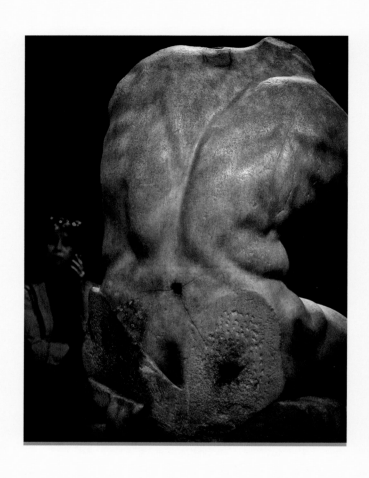

beacon of pure aesthetic pleasure, of persistence and invention. It's meant to inspire awe and respect, and, 460 years after Michelangelo finished the design with its band of windows underneath the ribbed dome and the golden crown on top, it still has that effect.

I carried on through the building, stopping only to see a few pieces here and there. Since the crowds were thin, I stopped to have a good look at the Belvedere Torso, the muscular remains of a first century BCE sculpture of a seated man, slightly twisted and bent forward. Though it lacks its head, neck, both arms, and legs from the knees downward, with its flexed stomach muscles and powerful thighs you can still see clearly how emotion is present in its body. Once, at a dinner party in Rome, a woman I had never met before told me about how she sobbed unexpectedly the first time she saw this fragment of sculpture, and then she began sobbing while recounting the story. It might even be this sculpture that inspired Rilke to write "The Archaic Torso of Apollo," and so each time I see it I am reminded to consider the question of how I must change my life.

Michelangelo studied this torso and used what he learned about the body and the emotive language of motion when painting the nude male figures of the Sistine Chapel that are so infused with intent and energy.

I carried on through the courtyards and galleries and down the long hall of maps, into the Raphael rooms and past the contemporary art, until, finally, I entered the Sistine Chapel.

I looked at the frescoes around the walls and under the ceiling, at the images made in the late fifteenth century by Perugino, Botticelli, Ghirlandaio, Rosselli, Signorelli, and others. I noticed the back-and-forth narrative between the stories of Moses on one side of the room and of Christ on the other. Each detailed painting is meant to correspond with the paintings across the room. Perugino painted the journey of Moses to Egypt, which also includes the circumcision of his son. This event in the Old Testament was linked to the baptism of Christ in the New Testament, which Perugino painted on the wall directly across. The painters were commissioned by Pope Sixtus IV to represent the life of Moses along the north wall and the life of Christ along the south in parallel to demonstrate the relationship between the Old and New Testaments.

I walked along one side and then the other, stopping in front of Perugino's painting of Saint Peter receiving the keys to heaven. It is sharp and colourful and so much easier to see than what is on the ceiling, but these images on the walls have a stillness that is made more apparent by the sense of movement above. I looked a little higher at the portraits of the popes between the windows, that were painted by Sandro Botticelli. Though they are frescoes on a wall, they look like statues in a niche. And when I finally looked all the way up, I did not see a crowded tangle of images that must be carefully unwound, but a majestic framework of the past, of ancient wisdom supporting the first part of the

story of Genesis on its shoulders. This was the first time I had this sense of wholeness about the work. It seemed less of a riddle, and for once I didn't feel so irritated by it.

I wandered around the room trying out different vantage points until a seat finally opened on a bench and I was able to look a little more carefully at the way the ancestors suggest a connection to the older works by Michelangelo's artistic ancestors. Sitting there on the bench I could see the Old Testament stories on one side of the chapel, the New Testament on the other, the pre-Christian imagery on the ceiling, including the ancestors themselves, and Christ on the altar wall. Christianity in this room is presented as a culmination of the past, as though everything leads toward and connects in Christ.

Finally, I let myself think about my own connection to the Sistine Chapel, to the frescoes that occupy my thoughts. I asked myself why I want to be in this room, thinking about these images, and I wondered why I feel such satisfaction when I notice something new, or when I'm able to make a connection from one part of the ceiling to another.

Why this work, though, why the Sistine Chapel? It's not as though I decided one day all at once to seek meaning in my rootless life within the Vatican Museums. But I had lost some people who were important to me around the time that I first started to visit, and these losses seemed terrible and poignant, and I found these feelings reflected in the artwork of the Italian Renaissance.

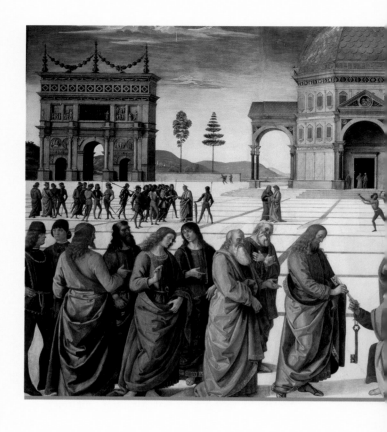

I felt compelled to see what would come of taking
the time to learn about the most challenging artworks
of the period. Was there more to such an experience
than intellectual gratification or aesthetic stimulation?
Would I find comfort? I saw that life was brief, that even
a long life was not long enough, and that the days of my

own were passing whether I did anything interesting with them or not. I wondered if I could learn something fundamental and unchanging, a universal truth perhaps, about what it means to be alive from a work of art that is meant to speak to the living about the past and the unknown future ahead.

I suppose it started with my mother. In her old age, my mother became confused. She got lost and wandered around Toronto, in the city she once knew so well. The inside of her head became a foreign place. We had been having a regular weekly phone call since I moved to Rome, but she started forgetting the schedule and even forgetting where I lived. It took several years, and it only went in one direction; until she could no longer recognize me when I visited, nor my brothers who saw her more often; until she couldn't speak anymore. She died on the inside, but her strong body kept going until after several years of this shadow life her heart stopped.

But before that final beat, my sister Marion suffered through a painful illness. She tried everything: doctors, medicines, healers, and herbs. In her final days, while she was in a hospice, I stayed at her house with her adult daughter. Marion had always believed that things happen for a reason and that everything works out in the end. Before she moved into hospice care, she wouldn't acknowledge the possibility that she might not survive, and she made it hard to imagine a force of will such as hers disappearing. When we stayed overnight, her daughter and I found handwritten notes in kitchen drawers urging herself not to give up. Inside the bathroom medicine cabinet there was a note stuck back behind the contact lens solution that said miracles can happen. Maybe they can, but none did, and she died.

My brother Ken didn't tell anyone he was sick, and he died alone in a hospital bed only a few years after

Marion's death. Ken had always led a life apart from the rest of us. Our mother often told me the story of how he had been very sick when he was born and was not expected to live. Someone called a priest who gave the baby extreme unction to prepare him for heaven, which is how he came to be the only one of us to be baptized. And then to everyone's surprise, he lived, as though a miracle had happened. He was by turns sensitive and brutal. He liked to read poetry and would thrash the boys who teased him about it. He had friends, and he could be sweet, but he never seemed close to anyone. He was very handsome when he was young, with dark skin, long straight black hair, and rich brown eyes. He was tall and strong. He had a brief period of calm when he married a wonderful, steady woman and they had a son, but he could not seem to hold still and was soon back on his own. It was easier for everyone to leave him alone, to let him live as he pleased. And so, it wasn't a surprise really that when his liver failed, due to cancer, though exacerbated by a life of heavy drinking, that he took himself to the hospital and refused to ask for anyone.

These were people I had known my entire life; for me they had always existed. And then, within a short space of time, they didn't. I had two much older half-brothers who died in their thirties when I was quite young. Though I remember them well now and I was very sad when they passed away, I saw their deaths for a long time as anomalies, until the rest of my family started to disappear and I had to acknowledge the fragility of what had once seemed

large and solid and that, as the youngest by several years, I might be the one to watch all of them go.

In the same year that I lost Marion, my husband's father died. James was on a work trip in Kiribati in the South Pacific when it happened. It took time to locate him, and when we did, he couldn't leave the island because of bad weather, and he missed his father's funeral. His father was ninety-two, and though his death was not untimely, for a man who'd not been ill it was sudden and somewhat unexpected. The last time we visited him in Waterloo, Ontario, where the family had lived for generations as the result of an earlier migration of Northern European Protestants (James's parents were Lutherans), was almost a year before he died. He held his grandson, his own child's son, on his lap and was comforted by the boy's blond hair, so like his had been, so like his son's. He remarked that Nicolas was just beginning his life as his was ending, but he was smiling as he said it.

Later, in the car, I reminded James of the couplet of Shakespeare's second sonnet "This were to be new made when thou art old, / to see thy blood warm when thou feel'st it cold."

The next year, James's brother-in-law Michael died suddenly, shockingly, unexpectedly. He had gone to work in the morning feeling unwell, and by afternoon he was in hospital dying from an internal infection that had gone undetected. By evening he was gone. James had to leave Rome immediately and fly to Toronto to be with his distraught sister.

And then James's mother died. James had time to go to Waterloo and to sit up alone with her into the night while her breathing changed and her body shut down and her heart stopped in the very early morning. While he was glad to have been there for her, he was shaken, shocked to realize that even a good death after a long life is still death. It's still the end, for ever and ever.

Our lives were so changed by our losses. Our world felt shrunken. It happened over a few years, but it felt like an instant. All these people we had always known no longer existed. I went to the Sistine Chapel to see something bigger than myself and my small, common sorrows. I wanted to see something enduring, something that outlasts its creator. I wanted to feel part of a world that means something, a world that continues; I wanted to feel that those we had lost were part of it too.

Inside the Sistine Chapel, the kind of art that had until then only been superficially visible to me became more vibrant, meaningful, and increasingly more relevant to my own life the more I looked at it. In galleries all over Italy, paintings that had seemed merely traditionally religious were now humming with an energy I had not previously noticed. And so, when I saw Giovanni Bellini's *Pietà* in Milan at the Pinacoteca di Brera, his painting of Mary and Saint John supporting the dead Christ, the suffering of Mary for her child reversed itself and reflected my suffering for my mother, whose name is Mary. When I look at it now, it reflects my suffering for my sister Marion and my brother Ken. In the painting,

Mary's grief is human and of this world; her loss is like my loss.

And though it seems on the surface to mean nothing really, my first name is also Mary. I was the youngest child and was named for my mother, who was the oldest girl in a Catholic family and was named after Mary the mother of Christ, and so I was named for her as well. It was while looking at that painting and trying to sort out the rush of feeling it produced that I felt grateful to have this link, this name that I don't use. My father named me Mary to acknowledge my mother, but he didn't use my name because it would be confusing to have three women in the house called Mary, Mary, and Marion (my sister was named after his mother). I have never used it because it indicates a religious affinity I don't have, but it shows I am linked to the chain that produced this artwork.

I HAVE NO EARTHLY REASON to be here, I thought, once again in a crowd of people with their heads tilted perilously backward. Staring at the Sistine Chapel ceiling serves no practical purpose. If I were to focus my energy on locating a shop that sells good cast iron pans and food processors, as I keep saying I will, I could buy them and use these things and they would have a measurably beneficial effect on my life and my family. If I concentrated on writing more articles and on my editing work, if I worked more quickly and found more stories, that would also have a beneficial effect on our lives in

a way that my staring at a remote and complicated piece of Renaissance art does not.

But I can't stop. I keep coming back, I keep going over it again and again as though civilization depended on it. And it feels that way, it feels as if civilization really does depend on it.

The sudden loss of people who were important to me forced a confrontation with the finite nature of my own life and made me want to feel something of the grandeur of humanity. I felt the flow of time backward and forward as it passed through the present moment as though it were all connected, like a story, or an epic poem, or a grand fresco.

IT DOES FEEL AS THOUGH something deep in my history made me reluctant to go to the Sistine Chapel, and now that I've crossed that barrier it feels as though the same thing compels me to go back again and again. On those rare times I've been able to sit under the frescoes and study the pieces of its narrative, study the visual connections from one part of it to another, I've felt like I'm figuring out how the world works and how my world has worked. Something about this place feels intimate and familiar, as though I knew something important about it long before I came to see it, and I have to admit that I did.

Since my maternal grandmother was French-Canadian, I grew up surrounded by Catholic imagery. She had crucifixes in all the bedrooms of the little Victorian row house in Toronto where she lived for more than fifty years. She had portraits of the Madonna, including a small one in a frame that she would hold while she prayed. She had a rosary hung over the edge of her dressing table mirror. The first image I can recall seeing of the Sistine Chapel was a picture my grandmother showed me of God and Adam. It was from a famous painting, she told me, and it would be so wonderful to see it. There was such reverence in her voice, as though she was saying how wonderful it would be to see the face of God — something both incredible and quite unlikely ever to happen.

My grandmother was born in North Bay at the end of the nineteenth century. Her family had been in the fur

trade for several generations, and she was among the first to leave that world and move to the city, to Toronto. That change alone was enormous. It moved her children into a world that was wholly different from the one in which she grew up. To my knowledge, my grandmother lived her entire eighty-nine years without ever leaving Canada. Seeing the Sistine Chapel frescoes would have been a dream she'd have never expected to realize.

I believe she used his name, that she said Michelangelo, because that name vibrates for me like a string plucked long ago that continues to make a sound. It has the ring of cultural memory blended with family history, in the way that knowledge passed through the family and the community seems solid and real and emotionally meaningful. I don't remember what she said, really, only that she conveyed a sense of awe. I can't even know if her reverence came from what she saw in the picture or whether it was from Michelangelo's reputation. There was something aspirational in it — that maybe one day it would be possible to see it, and wouldn't that be something, wouldn't that be meaning-ful. And like other aspirational things, it seemed to belong to another life; that a person who would one day see the Sistine Chapel would have to be a different person from her, or that if I were to see the Sistine Chapel, I would become a different person. I think about this now that my circumstances find me living down the road from the object of my grandmother's unrequited desire.

My mother kept a few culturally Catholic objects like rosaries and portraits of the Madonna, but she left the Church sometime after she started having children, when it seemed to her that it was oppressive to women, particularly to her. The only time I saw my mother go to church was when there was a wedding or a funeral. She continued to believe in God, but there was something about Catholicism that she felt compelled to reject in a way that I would only come to understand much later.

I'm certain my growing affection for representations of the mother of Christ come directly from the maternal side of my family, from the fact that my mother was called Mary and that my first name is also Mary. That my grandmother prayed to her image and that my mother carried a small devotional picture of Mary in her purse. But is there a direct line from that to me on the bench, looking at all the people Michelangelo depicted as Christ's ancestors playing with children, tending the elderly, combing their hair, sitting and staring out over our heads, and somehow feeling this has something to do with me?

The line is there, but it loops and curves over the ocean and across centuries. I've come to see how I am related to the historical period that produced this work, how so many of us are connected to it. The ripples caused by events of the early sixteenth century in Europe — the art, the violence, the rupture that would cause Protestantism, the very notion of nonbelief — are still lapping at our feet.

We can only see the narrative by looking back. The existence of each of us is really such an accident of fate. I still marvel at the fact that I live in a place such as Italy, that a work decision taken long ago landed me here in this unlikely city where my life unfolds, instead of where I grew up and expected to remain. But how did I get here? What kinds of twists and turns of fate had me being born in Canada? Where does my history begin?

I am the last person that anyone, including me, would expect to be making a personal map of meaning out of the Sistine Chapel frescoes. I grew up in a family in flight from Catholicism, the child of two people who might once have loved each other, but really did not by the time I was born. I was my mother's sixth child and my father's ninth.

My father brought three children from his first marriage to his relationship with my mother. And this was where my mother's trouble with Catholicism began. My father's first wife was a frail woman and a severe alcoholic. I know very little about her except that her alcoholism was serious enough to put the lives of her children in danger. When my father left her, he became the primary caregiver for their children. The problem was that he and his wife were Catholic and could not be divorced.

My mother was nearly eighty when she finally explained that my father asked her to live with him and help him care for his two sons and his daughter. My mother was barely twenty at the time, and my father

was ten years older. He told my mother that he would marry her when his first wife died, which was certain to happen soon given the state of her health. When I think of this now, I realize they were talking about a woman in her early thirties.

My mother agreed to live with him. They lived in Toronto at first, in rooming houses, my father, my mother, and his three children all together in two rooms and a kitchen with a shared bathroom down the hall. This arrangement continued as my mother gave birth to two sons less than two years apart, and then a daughter two years after that. More children followed before my parents left the city in search of work for my father, who was a carpenter, and a better life for their family. My mother used to recite all the names of the small towns in which they lived—Washago, Severn, Gravenhurst, Mount Albert—as though they were the stations of the cross, culminating in Keswick, the scene of her martyrdom and the place where my father died.

My parents had six children together, and though my mother wore a wedding ring and called herself by my father's last name, my parents never married because his first wife didn't die. When my father died of heart failure thirteen months after I was born, she was still alive. His first wife, his only wife, continued to live in the same unhealthy state as when my father left her, but she outlived him by more than twenty years.

My mother often cited the Catholic Church's opposition to contraception and safe abortion as her reasons

for turning away from the faith. She made it clear that she loved us very much, but it was wrong for the Church to expect women like her to spend their lives having babies. This system, she said, made poverty an inevitable part of life for a large family with only one breadwinner who never had fixed work and was always searching for the next job. It left them both unhappy, and each blamed the other for their circumstances.

It wasn't until my mother came to visit us in Rome when I was expecting my son that she explained that it wasn't only that she rejected the Church, but that she had so violated the rules of Catholic womanhood that the Church would have rejected her anyway. Even then, all those years later, she was conflicted about what she had done. She was angry at the situation my father brought her into, and she was angry that she had gone along with it, and all of that was complicated by the fact that she truly loved the children and grandchildren and great-grandchildren that were the result of this unhappy, unsanctioned relationship.

She was prompted to tell me this as we spent an after-noon wandering in and out of churches visiting the art. I suggested we find a church where she could hear Mass in English. I even suggested we go to Saint Peter's, where she could make her confession in English. She laughed and told me that there was not enough time left in her life to say all the Hail Marys they were sure to assign.

When I expressed incredulity that she could have done anything so awful, she confessed her sins to me.

It is terrible to think that she carried that burden alone all those years. For me, it illuminated a few things. Why I was allowed to go to Sunday school when I was little at any church I liked except the Catholic church, for instance. My grandmother used to like to watch *Hockey Night in Canada* and there was a young priest who would come over sometimes to watch it with her. My sister and I found him funny and charming, and we enjoyed his company whenever we found him at my grandmother's, but my mother wouldn't speak to him. My mother kept a few devotional objects, but she always claimed they were just sentimental family trinkets that held no religious meaning for her.

My grandmother remained a devout Catholic, although she knew of my mother's situation. She and my mother's sister did not judge my mother; they helped her and supported her. They're gone now so I can't ask them, but I suspect they cared about her more than they cared about their church. I don't think they made her feel guilty. But my mother couldn't seem to help but punish herself.

MY FATHER DIDN'T LEAVE US any money when he died. The small pension he had was paid out to his legal wife. There were many lean years and much struggle and I'm not really sure how she managed it with six children at home, but my mother kept us together and she kept us clothed and fed. She worked wherever and whenever she could, she took welfare when she needed it, she took all the retraining classes she could find, and eventually

she found steady work in the secretarial pool of a law firm in Toronto.

Through those years there was a pervasive sense of fear that seemed always right outside our door. And yet, my mother did her best to ensure that our lives were not grim. Our prospects were limited, our dreams were constrained, but my mother had a way of highlighting the small attainable pleasures that were available to us. We were habitual library users. We went to listen to stories, to read magazines, and to take books home whenever we wanted. The sense of luxury that my mother conveyed with her notion of the library still stays with me. We had tea on Saturday afternoons as a way of creating a ritualized pleasure. We took walks on summer evenings to enjoy the good weather, free of cost. And it was on those walks, during our breaks for tea, when she would try to offer whatever guidance she could for our futures. She urged her children to be practical. Find a trade, learn a skill, she would tell us. As we got older, she encouraged us to find jobs and to be good workers. And, mostly, we were. My mother didn't want us to struggle or to be poor. She simply sought for us the economic security she never had.

And so, after high school I found a job as a receptionist at a utility company in Toronto. It was respectable, and it pleased my mother. I earned enough to cover my expenses and to save a little too. I loved my job because I could read when it was quiet. Someone visiting the office once remarked approvingly that I was always reading,

and they assumed I was studying at university. I wasn't, but this made me think that I could. And so, I did.

I discovered that the cost of taking a course at night at the University of Toronto was minimal compared to full-time tuition, which I never could have afforded. I spent eight years earning an undergraduate degree in English literature part-time while I continued to work at various clerical jobs, and then another two years full-time for a journalism degree, while I continued to work at night. I studied literature purely for pleasure. The journalism degree was meant to be practical. It would be my trade.

This is the turning point in my life. And if I can connect anything from my past beyond the Catholic milieu in which I was raised to my interest in the Sistine Chapel frescoes, it is the experience of going to university and learning something for the intellectual pleasure of it. It is in the life-changing, brain-rewiring experience of studying the liberal arts. It is that experience that allows me to feel an affinity for the humanism that swirled through Florence when Michelangelo was growing up there.

The Renaissance was a period of discovery, a world of new ideas based on ancient texts and works of art. It was an exciting opening-up of the wisdom of classical thought and philosophy, but it was folded into the Christian ideas of the time. All the noble families ensured that their children were given a good humanist education. The Medici family of bankers would likely

have focused only on the money and not on the art that created the great city of Florence but for the fact that they were the beneficiaries of such an education. And those children became the patrons of the kind of art that expressed the glory of intellectual exploration and wisdom. The Sistine Chapel frescoes are entirely humanist in their framing of ancient pagan messengers surrounding the creation of the world and of man, the fall, and the destruction. When God gives Adam life and the freedom to make choices, along with the knowledge that his choices will have consequences, it seems like an encapsulation of the ideals of the humanities. It seems like something that relates to me.

It is the celebration of learning and knowledge that keeps me returning to that room. Inside the Vatican Museums and the Sistine Chapel you see that myths and stories matter, history and the search for meaning matter. It is my own unlikely, mostly haphazard, and somewhat humanist education that allows me to feel connected to this work, along with the strained Catholic environment of my childhood. The potential for wisdom or insight is something given to all humankind, but we must pay attention to it and nurture it. We must ask ourselves what to do with it, what to do with the gift of our lives.

Even if she couldn't say it plainly, I suspect there was a note of this in my grandmother's reverence for Michelangelo's Sistine Chapel. As though to see this great thing would help in some way to set a person on

the right path, it would change a person. I have seen it, but am I different as a result? Yes. To my own surprise, I think I am.

At university, I studied humanities, which are now widely considered to be the most useless course of study in the academy. I studied philosophy and history in addition to literature. For fun, I tried out Latin and a sprinkling of the classics. I already had a job, so I wasn't thinking about acquiring skills to make myself more employable. I only wanted to know about things.

I found myself often in places where I had never before imagined I would be: lecture halls, tutorial rooms, university libraries, even sharing a house with smart people who taught me to read widely, to stay up late talking about ideas and the world, and to feel that life could go in any direction. Before then, I had an unexamined sense of dread about what the future might hold, but it dissipated as I studied, as I began to feel that learning and thinking could give me a certain level of control over my own life. Being so free allowed me to reimagine myself and my future differently.

Looking at the Sistine Chapel ceiling started out almost as an obligation, though mixed with a little hope that I might find consolation there, and then it became a maddening puzzle. Its familiarity means that I can return to it in my mind with my eyes closed. The world seems different to me now that I've made this artwork a part of my life. The images I've studied have become my own, just as they can belong to anyone, they're not

exclusive. My mind drifts there while I'm doing the shopping or waiting in the doctor's office. I think about these frescoes, and thinking about them has changed the way I think about my own way of moving through the world, through time. My mind moves from the edges to the centre, to God and Adam, as I think about being alive, about existing now, and what it means to me.

WHEN I FELT I'D HAD ENOUGH for one morning, I slipped back out of the Sistine Chapel the way I came in, to retrace my steps and go back through parts of the museum, annoying guards and patrons alike by going against the flow.

The Vatican Museums house objects that represent the greatest impulses of humanity. These rooms are full of the evidence of minds seeking to understand themselves so they might know something about the world. There is a room filled with representations of animals — bunnies, donkeys, and dogs. Some of them are faithfully reproduced and others more fanciful. There are Greek and Roman sculptures and Egyptian antiquities.

There are the tapestries designed by the students of Raphael, huge tapestries of which every tiny stitch had to be made by hand. And there is Saint Peter's Basilica itself, representing the combined work of many great architects and artists; the effort to complete it spanned more than a single lifetime. The original Saint Peter's was built in the fourth century, but by the fifteenth it was collapsing. In 1505, Pope Julius II

decided to demolish it and build a new basilica with the help of the best architects of the Renaissance. Building began in 1506 and progressed with the support of a succession of popes until the project was completed in 1626, after 120 years of work. The dome I had been admiring from the courtyard looks much the way Michelangelo designed it, though he never saw it built, which is itself a testament to art as a human project rather than as a single individual endeavour.

I was looking for the Stanza della Segnatura, also known as the Raphael Rooms, which was part of the papal apartment that Pope Julius II used. In 1508 the pope hired Raphael to paint frescoes representing Truth, Goodness, and Beauty. He made two frescoes to represent Truth, and I wanted to look at his portrayal of rational knowledge in one of them, *The School of Athens*. It is an explicit homage to the ancients and to the humanist need to know the work of the great thinkers from the past. Raphael painted it while Michelangelo was working on the Sistine Chapel ceiling, just down the hall.

Historians describe this room as the centre of intellectual culture in Rome during Julius II's papal tenure. Raphael painted a gathering of ancient thinkers using techniques and styles that he and his contemporaries were perfecting. He used likenesses of Leonardo da Vinci and Michelangelo to represent Plato and Heraclitus, and in doing so signalled the continuation of thought and exploration.

I took my place in that room with everyone else along the wall across from *The School of Athens*, but when I turned to leave, I noticed the scratch marks on the decorative frescoes below. If you didn't know what they were, you might think they were the senseless scratchings of bored adolescents on a school trip. And a few of the marks are exactly that, contemporary museumgoers who for some reason have decided to add a mark or two of their own. But others were made by the soldiers who sacked Rome in 1527. It's a reminder of differing experiences of the world. Above is all cerebral intensity about the forward march of human greatness and the accomplishments of rational thought. And then, underneath,

are the marks of the invaders, who, it is important to recognize, were poor, desperate, and exceedingly angry. They were an army for hire, made up of men who mainly wanted food and money but who were also enraged by the obvious excesses and riches of a church that they had come to see as wrong, and possibly as evil.

The graffiti is all that physically remains of their rage. There's something in it, though, something in my proximity to the marks, which were cut into the plaster with a knife, that feels familiar. The scratches are a reminder of a kind of rage that was around me as I was growing up, that I was surrounded by and that I think comes from a sense of having been cheated, of injustice. It was there in my house despite my mother's attempts to stifle it, in the holes my brother Ken punched into his bedroom walls; all the rage that was produced by our constricted circumstances, our poverty, and what felt, in those days, like the impossibility of any of it ever changing. It was in all the houses around us, up and down our street. It was the rage of grievance compounded by powerlessness and hopelessness. This wasn't a longing for material comforts so much as it was a desire to have a respectable place in the world. The rage came from the unarticulated, though I imagine deeply felt, longing for the universe to not be harsh and arbitrary but to have a design, a plan, and for it and us to mean something.

I never experienced any of that violence directly. It was never aimed at me. Even within my own family,

there were quiet, almost opaque references to the rage of my father, but he was gone when I was growing up, he was already dead and harmless. I was living with the effects of it on my family, one step removed. In the different places where we lived, I heard notes of anger, I was quite attuned to it. My mother would comment on it vaguely and indirectly, as though she didn't want to talk about it but couldn't really stop herself. It seemed to me as a child that there was an atmosphere of anger, of boiling rage inside people's houses and short tempers out on the street.

In this room in the papal apartment, I imagined the rage of the invaders. I think there were many things going on at once. These were soldiers and they had come to loot and destroy, to recover the money they were owed as mercenaries. The obvious wealth of the Church was a provocation, but many of them were also responding to the charges made by the reformers against the Church in Rome. They were inside the Apostolic Palace, in the rooms used by the pope and the cardinals.

It is surprising that the soldiers did not destroy the place, but the Prince of Orange, who was among the leaders of the invasion, had moved into the palace to recover from injuries and gave orders to the troops to leave it alone. The body of the Duke of Bourbon, who led the troops to Rome and then died on the first day of battle, had also been laid out at the altar in the Sistine Chapel, which is likely what saved it from being vandalized.

Despite the presence of the dead duke and the convalescing prince, some soldiers still entered the Apostolic Palace deliberately to leave their mark. They left a clear message at the bottom of the fresco opposite *The School of Athens* which shows that this wasn't an act of senseless vandalism but a targeted and focused furious message.

The Sack of Rome involved looting and vandalism of all kinds, but it was also a massacre. And when the invaders after many months were finally finished with the city, its population had been reduced to less than a third of what it had been.

The frescoes in the Stanza della Segnatura, particularly *The School of Athens*, are about finding answers through rational inquiry, through thought and history and art and philosophy, and, of course, through God and the Church. The violence is also about seeking something, or perhaps it's about trying to settle the answers to questions about how the world works.

The violence happened everywhere, the streets were piled with corpses and rubble, but there is no trace of any of that now, five hundred years later, except in the graffiti in the Villa Farnesina and, even more so, here in the room with Raphael's frescoes.

When I was growing up something was missing in our lives, in mine and some of my friends, and there was no obvious, discernable target for our parents' anger. I remember sitting in the backyard with my friend from next door and listening to her parents fighting. The sound of their screaming at and over each other is the

sound of rage, of a roar, of a vortex of anger. As an adult analyzing the things I didn't understand as a child, all I can imagine is that they felt a need for relief from the harshness and the limited scope of their existence and for their lives to mean something. That heightened atmosphere of anger and my own reflexive feeling of vigilance formed a knot deep in my brain.

Of course, none of this is the same as the Sack of Rome, but in the room with Raphael's frescoes, I recognized the anger and I remembered the fear and I knew that those feelings are of a kind.

It was worse in my family before my father died, though the loss of him did not end our troubles. We stayed in Keswick for a few years and then moved to a farmhouse near Sutton, where my mother kept the books for the farmer who owned both it and the farm next door. She worked for him and in exchange we could live in the second farmhouse. We grew vegetables there. Two of my brothers had left home by then. The other two sometimes helped our landlord after school. It was difficult and remote, and the house was freezing in the winter, but we all remember it as a reprieve. There was fresh air, there was room, and it was quiet.

But the worry that comes from living on so little, from worrying about money and security, was still there, and it intensified as we moved around, as we made our way through small towns looking for a way to live. My mother's fears for our individual futures were always present. My siblings still carried the effect of our father's anger.

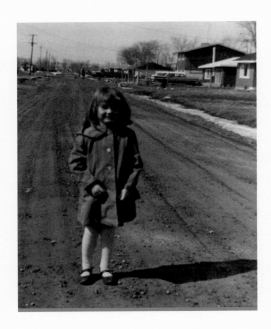

The violence, too, was still out there. I remember the women huddling over the teapot in the kitchen of the house where we lived on Lake Simcoe, circling around and protecting someone, speaking in hushed voices so the children wouldn't hear.

This moving and searching for something better, my mother's hope that it was possible to regain a level of respectability that she would only have known before she married my father and, I suspect, her battered faith in God and belief that life has meaning gave her some sense that our lives could be different if she could figure out how to guide us. In these small towns where I was growing up, the chaos, the unformed matter of our small

universe, the inarticulable sense of its enormity and of our own insignificance and our sense of hopelessness, our inability to understand what it all means was so often met with fury.

The kind of rage I heard and felt as a child seems to me to have been something like that of the Landsknechts who roared into Rome in 1527, who brutalized Roman citizens and left their mark of disrespect upon the artwork. They wanted meaning. They learned that nearly everything they had believed about faith and penance was a lie and that the true path to Christian righteousness did not lead to Rome. Luther told them that nothing they could do could get them into heaven. They could confess their sins, buy indulgences, climb the holy stairs on their knees, visit all the churches in Rome, and hail Mary until their voices cracked, and none of it would help. These were simply corruptions created by papal authority. One of the ways in which Lutheranism diverged from Catholicism was that Luther believed that a Christian could not confess and perform a few tasks and expect all sin to be forgiven. He believed that people must look deeply within themselves and must wrestle with the Christian story and eventually emerge with true faith in Christ. The prayers and actions of a Lutheran should come from a place of unshakeable faith and be done to honour Christ and not to ask for special favours. Of course, this made the sale of indulgences that much more contemptible to a fledgling Lutheran.

Though the Holy Roman Emperor Charles V was fighting other wars in Italy, his troops were moving closer to Rome because Pope Clement VII had formed an alliance with a French league to challenge Charles V. But it was the unpaid soldiers who invaded on their own initiative. In some ways, these marauding soldiers had a deep and meaningful experience of the art of the Renaissance, filled as it was with images confirming the Catholic understanding of scripture. It's just that they hated it.

I've talked to people who have left the Sistine Chapel and who can't, even a few minutes later, recall much of what any of it looked like because it seems so removed from their twenty-first century lives. Many of those who rode into Rome in 1527 with the intention of destroying it knew that Michelangelo's ceiling was suspiciously pagan, suspiciously intellectual and humanist, and that it was filled with nudity. They saw it and the whole opulent direction of the Church of Rome as a provocation and as proof of Satan's work. They were worried about where it was all going to lead in the future. They were worried about us. And as I stood there looking at the marks they left behind, it occurred to me that I was quite likely the very embodiment of their fears: an unaccompanied woman, an agnostic looking at art for its beauty and secular meaning.

A large tour group moved into the room while I stood studying the graffiti and trying to make sense of the familiar and unwelcome feelings this evidence of rage evoked. The guide was quietly directing their attention

to Raphael's contemporaries painted into *The School of Athens* and to the artist's self-portrait painted into the far right, his young face looking open and naive, looking not at all as you might imagine the person who could paint such a complex idea of intellectual life might look. This world of thought and rationality seems so peaceful.

But what they are doing, these thinkers and artists, is taking the inchoate, the unsayable, and they are trying to say it, whether through philosophy, math, astronomy, or painting; they are trying to touch that central core of us and our universe and to make us feel it, like God touching Adam. And it is possible to feel yourself deeply inserted into the long march of humanity and to see it carrying on. It's a humbling and grand feeling all at once.

I took a photo of the place where the date 1527 was gouged into the wall, while those around me took photos of *The School of Athens*. Right across from this fresco is another by Raphael called *The Disputation of the Holy Sacrament*. Raphael painted it a few years before Luther started to provoke the pope and at a time when there was little dispute about whether or not the bread and wine of the Eucharist actually becomes the body and blood of Christ. This painting is the companion to *The School of Athens* because this one is about revealed truth, or supernatural truth as it is sometimes called. The painting shows God, Christ, and Mary, among others on a cloud, while on the ground are gathered some of the saints alongside Pope Sixtus IV and Dante Alighieri. They are not disputing the doctrine of transubstantiation, as it is known in the Catholic Church; they are receiving this wisdom.

One of the soldiers scratched the name of Luther into the plaster at the bottom of the fresco so that when the light is right it is visible, a symbol of competing views of Christianity. Luther believed that Christ was present

in the celebration of Mass but that the bread and wine simply represented his body and blood. It might seem like a small point to us now, but it is one of the main reasons that Luther's challenge to the Church could never be resolved. This was one of the fundamental points of difference in the interpretation of scripture. The soldier who scratched Luther's name into the bottom of that fresco was making a pointed message with his knife.

I had to go back through the Sistine Chapel to find the exit. My neck was already strained, and my back hurt from my earlier visit, but I couldn't resist taking a few minutes to look again at God furiously separating light from darkness, powerfully creating order and form out of disorder and chaos. The Church knew how to use art as a tool for salvation. But I had to wonder, what could it save us from now?

THE CORNER PENDENTIVE PAINTINGS

Looking for Salvation

In the corners of the chapel's ceiling, Michelangelo painted what are known as the four pendentives. These are scenes from the Old Testament that are meant to show good triumphing over evil. They represent specific instances when the people of Israel were saved from a threat.

Michelangelo had to adapt to and work with the shape of the ceiling itself, and he softened the corners by creating stretched-out, curved, inverted triangles to hold these discrete images in the four corners of the room.

The paintings *David and Goliath* in one corner and *Judith and Holofernes* in the other are at one end of the chapel nearest the story of Noah and the flood. At the other end, and just above the altar wall, he painted *The Death of Haman* and *The Brazen Serpent*.

Before going to look at the pendentives, I spent some time studying up on these images from the comfort of

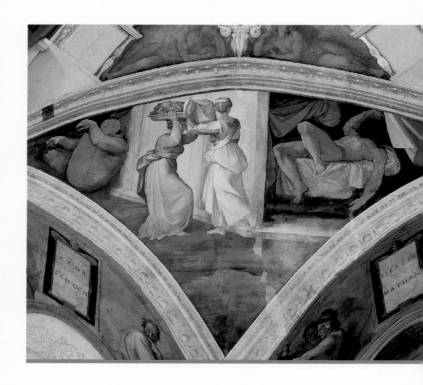

my own living room, where I was directed by my reading
to notice the difference in style between the paintings at
each end of the chapel. Michelangelo painted the David
and Judith pendentives close to when he started the
project in 1508, and he painted the other two toward the
end in 1512. Some historians have noted that his painting
style evolved so much that it's like looking at the work of
two different artists. I wondered if it was also possible to
discern a stronger sense of good and evil, a darker view,
a desire to linger on the suffering of the wrongdoers.

In *David and Goliath*, Michelangelo has painted the boy after he has knocked the giant down with a stone from his slingshot and just as he is about to cut off his head with Goliath's own sword. It's the triumphal moment when the young Israelite slays the huge Philistine and saves his nation. It's good triumphing over evil represented in a single scene. It's also the intelligence of the small boy, who knows to hit the giant in the middle of his forehead with the stone from his slingshot, claiming a victory over brute force.

In the next pendentive, Judith has already cut the head off the Assyrian general Holofernes, who has just taken over her village. This story was more gruesomely depicted by Artemisia Gentileschi more than a century later. In Gentileschi's version, Judith and her maid are hacking at the drunken general's neck with a sword. In Michelangelo's, the maid is holding the massive head of Holofernes on a tray while Judith covers it with a cloth. There's a visual link between these two pendentives, with David about to behead his giant in one corner and Judith in the other corner covering the severed head of hers. Again, the underestimated good person triumphs over the crude strength of evil.

I stood at the one end of the chapel looking up at these two images for as long as I could tolerate the bumping and pushing of the crowd surrounding me and then circled back toward the entrance and the altar wall to look at the other two corners. *The Brazen Serpent* and *The Death of Haman* represent more complicated stories,

and they linger more on punishment than on goodness. *The Brazen Serpent* comes from a story in the Book of Numbers where God punishes the Israelites who have been complaining about God and Moses for leading them out of Egypt only to take them to die of hunger and thirst in the wilderness. God sends them a plague of "fiery serpents" in response. When they have been sufficiently chastised and have repented, God tells Moses to make a fiery serpent and attach it to a pole and to raise it. All those who would look upon it would live if they were bitten by the serpent. In Michelangelo's depiction, however, a few people on the right of the snake are calmly reaching toward it as though to be saved while many more people on the left are being bitten, squeezed, and killed by snakes. The composition of this painting is often described as an echo of *The Last Judgement* where the saved are on Christ's right and the damned on his left; though it could be that those on the left represent the complainers dealing with their plague of snakes and the right shows what happened afterwards when they were sorry and grateful to be saved. In any case, it's the writhing mass of limbs and snakes and horrified faces that takes up most of the space.

In the other corner, Haman is attached to a rough-looking crucifix, with his muscular body twisted, his arms outstretched, and his head thrown back and to the side in an exaggerated pose of agony. Again, good triumphs violently over evil, since Haman was plotting to kill all the Jews in the Persian Empire and had

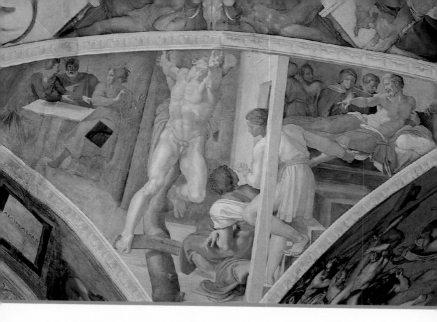

convinced the king that this should be done. Haman is described as greedy, devious, and arrogant in the Book of Esther. He was particularly bothered by Mordecai (the man who had raised Esther, the King's wife, as his own daughter) and had gallows built specifically to hang him. Instead, when Esther makes it clear that she is Jewish and that she and her people would be destroyed by Haman's plot, the King has Haman taken to the gallows to be hanged there instead of Mordecai. It's not known exactly why Michelangelo showed him being crucified; it could be because of a translation issue in the Vulgate Bible or because Dante describes Haman being crucified in the *Divine Comedy*. The subject is clearly that evil will be repaid with pain.

Walking around the room looking from one corner to another, I could see how the pieces of the entire work come together. There is a logical way to unravel the images on the ceiling by following the way that Michelangelo designed the whole thing. Down the centre, the part where our attention inevitably goes first, is the story of creation and the fall from grace, the fatal moment that created what we call the human condition, so that we inherit the sin of Adam from birth and must choose Christ as our saviour if we don't want to spend our afterlife among the damned. And so, even though Christ isn't in the central panels, the narrative of his impending arrival is being told. Surrounding this story are the pagan sibyls and the Hebrew prophets, who hint at the coming of Christ. Encircling them are all the people who lived from Abraham onward having their children until eventually a very human Christ is born. The four pendentives are like the stakes in the four corners of a tent, grounding everything with the insistence that goodness will overcome evil, that we must choose goodness. Michelangelo uses the serpent being raised on the pole and shows Haman being crucified as a visual reminder of Christ's sacrifice on the cross, insisting that it is Christ who must be chosen. Haman being justly crucified saves the Jews, while Christ's unjust crucifixion saves humanity.

As I walk around the room, I feel the way Michelangelo's sense of conviction builds as this extremely devout painter tries to show the path to salvation. He builds his case from

the centre outward and shows that Christ's coming was known; we have been told, and we have been warned. There is something so compelling and insistent, and as I walk around the room I can see and feel the sincerity in the call—you must choose goodness over evil. I can accept that much. But how do we know goodness from evil? That seems a question that the Church itself cannot answer with confidence.

BEFORE I CAME TO LIVE in Rome, the city seemed like a mythical place to me. Once it had been the centre of an empire, and later it was the centre of Christendom. The expansion of the Roman empire and the later spread of Christianity were carried out by people motivated by power, authority, and greed, but we often forget they were also motivated by some firmly held convictions. Romans believed that their society and way of bringing order to the world was superior to that of their enemies. Christians believed that theirs was the one true God.

Ancient Rome endured through wars and threats and expanded until the centre could no longer control its extended, conquered territories; it started to lose ground, and the unthinkable happened—the Empire fell. Eventually the culture of the ancient world, as it was expressed in the art and architecture of its time, was taken up again by the artists of the fifteenth century who went out to study the ruins, the broken pillars and cornices of the ancient city, to study the joints and decorative details, to read Plato and Virgil.

Pope Julius II put these artists and craftsmen to work rebuilding the glory of Rome through the Church and through art.

This city is a great reminder of the fragility of any ideas we might share about Western civilization and progress. A few days walking around Rome can be an unsettling experience and not only because of what it is but because of the ruins of what was, the remnants of big ideas, the traces of what was meant to be good triumphing over evil, civilization over barbarism, the certainty of one side's superiority over another's, and the traces in the ruins of what was meant to last forever.

Contemporary Rome bears this enormous weight of significance and looks exhausted by its burden. The centre is kept barely presentable, but around the edges it's a mess of dense and ugly apartment blocks, cars, graffiti, and garbage. The chaos of time seems to press in from the outside on a place that once saw itself as the centre of the world. Rome is not a museum but a living city, and people do live in it, they carry on with their daily lives. I mean, we do. We go to the market and the bank; we go to the shops to buy new shoes. We get on the filthy subway trains to go to work, to school, to church or synagogue or mosque, to the museums and galleries. We pick our way over broken sidewalks littered with garbage. A succession of city governments have seemed unable to cope with the ordinary problems of running a city, let alone the problems of an ancient one filled with fragile pieces of the past.

When another spring finally came after what felt like a darker than usual winter, I told James it reminded me of our early days in Rome, of the Rome that I first loved. "Where is that Rome?" he responded. "Where has it gone?" We tried to figure it out, but it seems as far in the past now as the world of the caesars. We moved to Rome shortly after Pope John Paul II had declared a Jubilee year, and so the city had been somewhat fixed up for the Christian pilgrims who still see it as the capital of Christianity. It was the new millennium, and Italy had just switched from the Lira to the Euro. There was optimism and a sense of order. Even though Silvio Berlusconi was the prime minister and the picture of the buffoonish conman as statesman, and even as he turned the clock back and welcomed a new era of chauvinism, racism, and corruption, even still there was a sense that this would pass. Even still, we all expected that goodness, as we understood it, would prevail.

Maybe there was no good reason for our buoyant outlook. The financial crisis that came in 2008 caused developers to leave half-built apartment blocks to become ruins without ever having been homes. There's one near my house; it has big modern balconies and a swimming pool on the main floor. Its white exterior is now scrawled over with spray paint. It has the wasted, tragic look of dashed hope. Sometimes, I've seen faces looking out of the glassless windows, and realized that people must be living in this unfinished structure like ghosts, as though in a shadow world of the one that was meant to be.

I went out to run some errands one morning and caught a bus to the centre. Speeding along the Lungo-tevere was once one of my favourite things to do. The road follows the curve of the river in a pleasing swoop, the bus flying past the Ponte Rotto, a raggedy-edged chunk of an ancient Roman bridge stuck out in the river disconnected from land, and then the Ponte Fabricio and its sculpted stone faces at either end, almost completely worn down by time and weather. The curve of the river, the tall plane trees, the ancient and the very old all come together as the pieces of a whole that can only be Rome. But on that morning, I saw that it was all obscured by the layers of graffiti that now cover the embankment walls lining the Tevere, the Tiber river, and reach as far as the ancient bridges.

For a few weeks, there were photographs in the Metro stations taking up places usually used for advertising, images of Rome bathed in golden light. They must have been taken at dawn because there were no people in them. The bridges were empty instead of crowded with traffic and tourists and angry men and women on motor-bikes. Were they meant to remind us of what the city is supposed to look like — dazzling, solid, and eternal? The ideal Rome rather than the actual?

As the bus moved toward the centre, I was hit by the violent dissonance, by the angry-looking snarl of garish colours, of giant block letters and looping script, by the clamor of unknown people demanding acknowledgement, like the French police officer who was caught scratching

her name onto a wall at the Colosseum. She had no real explanation for her actions other than a need to mark her existence.

The bus passed a large stone marker along the river that notes when the embankment was built up. It took me a long time to understand why it said *Anno IV*. A friend pointed out that it was built under Mussolini in the fourth year of fascism. The fascist government was so convinced of its mission and of its strength, of its own goodness, that it renumbered time.

As I read the contemporary fascist and antifascist curses scrawled on bridges, walls, and roadways in the heart of Rome, it felt like something was about to break. All these angry threats of annihilation, each against the other, betray the tension. There were soldiers with automatic weapons in the Metro and armoured vehicles placed in pedestrian areas to prevent anyone from using a car or a truck as a weapon in a crowd. The streets of Rome had changed with the arrival of thousands of refugees from Africa and the Middle East, people fleeing violence while they were simultaneously being perceived as a threat to the cultural order.

I got off the bus and walked through the Roman Ghetto, past the armed guards outside the synagogue, toward an art supply shop where I could buy watercolour pencils for Nicolas's school kit. I also had to buy a book as a birthday present for his friend. These were errands, simple tasks that I could tick off the list that I kept in a plain black notebook in my purse. I had only bought the notebook recently and decided to devote it to daily lists in another attempt to be grounded and practical. When I write out my chores in the mornings, I imagine I'm making the centre hold, I'm preventing the pieces of myself from flying off in the vortex of an ordinary life. I never before understood that stationery could have such salvational possibilities. I make work lists on the left side and household lists on the right and spend the day keeping them in balance. On my way home, I'll buy a piece of beef and a bottle of wine, as I have reminded

myself to do on the right side of the notebook, and I'll
rip a couple of laurel leaves off the neighbour's hedge
to throw in the pot with the meat, and then I'll make
satisfying check marks against the completed tasks and
feel like the day was successful. I'll have held off the
encroaching chaos, that dimly perceived sense of threat,
once again.

I walked over brass cobblestones placed in front of
doorways to indicate that the people who lived there
in the 1940s were one day forcibly taken to die in a
concentration camp.

These stones are all over Rome but there are more of
them in the Ghetto. I continued through to the market in
Campo de'Fiori and glanced at the dark, hooded statue
of Giordano Bruno, placed up high and looking over the

piazza, who was burned at the stake near that spot in this piazza in 1600.

> ...His crime was his belief
> the universe does not revolve around
> the human being: God is no
> fixed point or central government, but rather is
> poured in waves through all things. All things
> move....

I think of Bruno being silenced, as Heather McHugh writes in this poem called "What He Thought." She describes the executioners placing an iron mask over his face so that he couldn't speak; others have described a spike driven into his tongue or a leather strap tied to his mouth to hold his tongue still. The point is that he had to be silenced since he was known to have been persuasive and eloquent.

The spring sky turned grey over Bruno, and the unexpected wind rattled the metal poles supporting the shelters over the fruit and vegetable sellers.

There are some days when it's possible to run these kinds of errands through the centre of Rome and see it simply as a very old, unique, and beautiful place. But most days I can't help but feel the current of violence, of organized and bureaucratic human brutality. This kind of violence is a measured and considered reaction to something that threatens a perceived sense of order, a reminder of the difficulty of knowing good from evil.

I FINISHED MY ERRANDS a little sooner than expected. And since I was already in the centre, I decided to visit Santa Maria sopra Minerva, a church to the side of the Pantheon that was built near former temples to Isis and Minerva. Saint Mary over Minerva, who was the goddess of wisdom, art, and war, among other things. I like the juxtaposition of the Christian saint with the Roman goddess. Though this basilica is known for housing the remains of Saint Catherine (all except her head, which is in Siena), it also has a marble sculpture of Christ by Michelangelo.

This basilica had been an official office of the Inquisition in the seventeenth century, and Galileo was brought in front of it to denounce his own theories. The idea of the Inquisition was to keep order, to keep chaos and dissent out of the Church. The Inquisition was meant to make the centre — orthodoxy — hold. Impure ideas had to be cleansed with fire. Galileo's discoveries were not just a threat to orthodoxy, they were terrifying and awe-inspiring. The Church could not accept that the Earth was not at the centre of the universe. If this were true, it would call into question everything Christianity believed about its place and humanity's importance. Galileo was summoned by the Inquisition, pronounced a heretic, and forced to retract his theory. He did recant, and who could blame him given what they had already done to Giordano Bruno? "Eppur si muove" is the phrase that Galileo is said to have muttered after his trial, though there is no real evidence to support this claim.

rose from the grave. The original commission to Michelangelo specified only that Christ be shown naked and with the cross, the rest was up to him. I stepped closer to the statue. Michelangelo has positioned his Christ in contrapposto, with his left leg supporting his weight and his right bent so that his right hip rests on the lower part of the cross that he holds in his arms to one side. The pose was revolutionary in art terms when it was first invented. It allowed artists to move away from stiff figures and to create realistic bodies. In this case, the pose helps to emphasize that Jesus was human and that his suffering was real. I saw small square holes on both his feet and hands. The nails used to crucify men at that time were heavy, iron, and sometimes square. I don't know if this was Michelangelo's intention, but the sculpture seems to embody the idea that what is to happen hasn't yet, but the inevitability of it is already present in this very human body, which will feel the nails and the crown of thorns, just as we would if it happened to us.

So many depictions of Christ after the crucifixion dwell with lurid intensity on the wounds and the blood of his human body. The violence that was done to Christ is displayed in fetishistic detail. The five holy wounds are the nail wounds in both hands and feet plus the lance wound in his side where a Roman soldier pierced him to make sure he was dead. I can't claim to understand the devotion to the evidence of Christ's violent death except that it seems to point to a long history of people doing

terrible things while acting in good faith. I also don't understand how his death is supposed to have saved us. It always seems to me that the crucifixion ought to be a caution against righteous violence. I can't get past the very realistic sorrow attributed to Mary after his death, the sorrow that is probably best represented in Michelangelo's *Pietà* in Saint Peter's Basilica. I can't move past it and onto the resurrection and all that it is supposed to mean about eternal life. I still see this part of the story as a terrible lesson that is never heeded.

On Ash Wednesday in 1600, Giordano Bruno, a philosopher and a Dominican priest, was stripped naked by the followers of Christ and then tied to a stake in the square that is now, as it was then, the fruit and vegetable market of Campo de'Fiori. He was burned to death, and his ashes were scattered in the Tiber. Nine days before, he had gone through a process called "solemn degradation" where, over the course of several hours, a bishop removed each of the items and permissions that had designated Bruno a priest. I can only imagine the pain of that process to someone who was trying to argue that the upholders of orthodoxy were thinking too small and that God was much more grand than they had ever imagined. He might even have frightened them a little when he told his inquisitors that they should be more afraid to bring the sentence against him than he was to accept it. All his writings were placed on the Index of Forbidden Books, although copies still managed to get around in the years after his death.

Bruno died almost a hundred years after Michelangelo painted the Sistine Chapel ceiling. The humanist ideas that influenced Michelangelo also influenced Bruno, yet one of them was considered divine and, some decades later, the other a heretic.

I think of my mother and her faith, her love for the Catholic culture in which she was raised. And I think of how she suffered because she acted out of love for another person, that her love first for my father and his children and then for the children they had together was stronger than her love for the Church. She suffered because of that inner conflict, and we felt her suffering without her putting it into words. She defied what the Church said was good and took the risky step of doing what she felt best, certain all the while that she would eventually be punished.

The Catholic Church has never really apologized for what it did to Bruno. In the Jubilee year of 2000, Pope John Paul II said that Bruno could not be pardoned because he strayed too far from Christian doctrine. Bruno believed that there was no centre to the universe because it was infinite. He quarreled with his inquisitors, who kept him in prison for eight years, about the finer points of heresy until they had finally had enough and sentenced him to die. Pope John Paul II said that those who put Bruno to death should be judged by the times in which they lived, but that the Church regretted the violence that was done to him. Earlier, this pope admitted that the Church was wrong to have condemned Galileo.

But Bruno had also questioned the divinity of Christ, saying that Christ was not literally the son of God, and the Church could not agree with him. He was sentenced to die because he refused to believe that the bread and wine of communion was literally transformed into the body and blood of Christ, and because of several other points that the inquisitors considered heretical, though Bruno said the inquisitors did not have the right to decide what was and was not a heresy. His real crime seemed to be that he challenged their authority to decide what was good. They asserted this authority by showing him that they had the power to end his life.

Bruno was silenced so that Christians would not hear the dangerous words that he might say, so that no one would imagine that the universe is vast, that we are not at its centre, that we are insignificant, and that God might not be what we think.

Giordano Bruno was a victim of the Renaissance, in a sense. He was influenced by the ideals of that period when philosophical, scientific, and all other forms of intellectual inquiry were understood to be more illuminating to Christianity than threatening, when Giles of Viterbo could study Judaism and the pagan world to look for Christian insight.

My mother was a victim of the kind of Catholicism that emerged over the centuries after the Counter-Reformation — the Catholic response to the Protestant Reformation — which produced a church that was more concerned with itself, with its rules, with maintaining

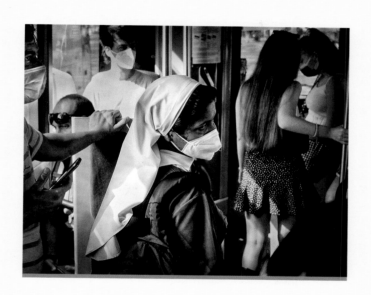

its power in a fractured world than with the real lives of individual Christians, particularly women.

I circled back through the market on my way home with my shopping. There was the inevitable pigeon standing on Bruno's head, and a few people rested on the steps below the statue. There were also the remains of some flowers and an extinguished votive candle, likely an offering to the heretic-philosopher.

I carried on, leaving ancient Rome behind me as I passed the memorials to the victims of fascism and caught my bus, settling into a seat for the bumpy ride through the centre of a city that contains the layers of so much human striving toward power and righteousness. I pulled out my notebook and checked off the items on the to-do list, and then I looked out the window at the traffic on the Lungotevere and at the water in the Tiber, both flowing as though with a purpose, as though it all knows where it's going.

THE ARTIFICIAL
ARCHITECTURAL
SUPPORTS

What Holds the World Together?

"It looks real, but it's an illusion. It's just paint." I overhear a tour guide telling this to her group and, at first, I think she's talking about the whole ceiling, that the whole Sistine Chapel ceiling is a piece of fakery. As I stand there considering her harsh assessment and wondering what kind of art she might consider real, I realize she's talking about the architectural structure that Michelangelo painted to hold the separate parts and pieces of his sprawling story together.

There are painted columns that look as if they're supported by chubby toddlers, the putti, and there are what look like marble ledges and frames that keep one image from spilling into another. Tucked into the framework there are naked, orange-skinned men, some with long skinny fingers, that have been compared to the kind of grotesque figures that appeared in Roman painting. There are other naked though more sculptural male bodies, the ignudi, sitting on the corners of the painted marble surrounding the central panel of images.

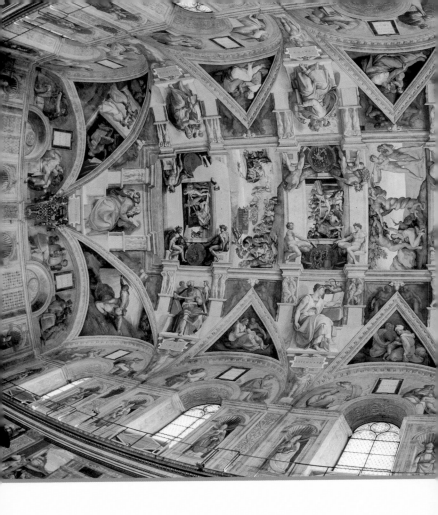

Some of them carry bundles of oak leaves and acorns, making a visual connection to the name of Pope Julius II, who was Giuliano della Rovere before becoming pope, and rovere means oak in Italian. The figures are decorative, and most historians don't overthink them or try to

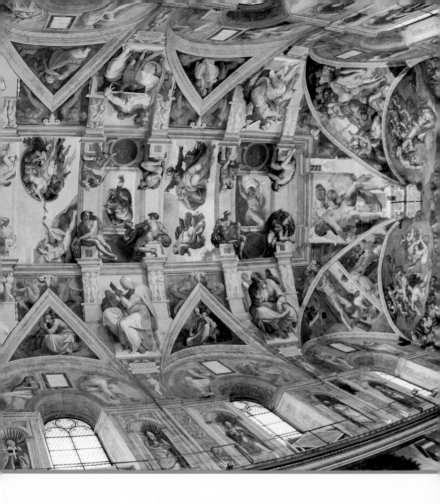

read too much into them. The ignudi hold onto ribbons threaded through circular bronze pieces that look like huge medallions. These contain additional images from the Old Testament, as if to say there's more, and even here there isn't enough room for the whole story.

The tour guide explains that painting an architectural structure (trompe l'oeil, essentially) was a common enough technique in the sixteenth century, and artists used it to blur the line between the actual building and the fresco, between reality and the image. I step in a little closer to her group as she directs them to look up toward the central panels and to notice the way the painted structure has taken the roof off the chapel. Rather than looking at images on a ceiling, the painted architecture makes it look as though the nine central panels are floating way above our heads, outside and above the building.

From the floor, it's difficult to tell what is painted and what is part of the building's actual architecture. The painted structure provides a framework for the images and stories to unfold, and it even gives the sibyls and prophets something to sit on. These images of marble supports and ledges look like they're supporting the building rather than providing the scheme to hold the frescoes together.

Over these few years of here-and-there visits, I hadn't before noticed the function of this fictional architecture. But it must have been one of the awe-inducing elements of its day. It must have seemed like a bit of magic for the artist to open the ceiling and reveal the story of creation and destruction. He used this trompe l'oeil technique to provide a strong and elegant structure to contain his story of the Old Testament world, and even to suggest a link between the earthly building itself — the Sistine Chapel — and the heavens above.

It's all an illusion, as the tour guide said. All these arches and braces, columns and ledges, everything that appears to be supporting the story of the Christian world is just paint.

I CAN ONLY IMAGINE that the shifting rules and structures holding Catholicism together must have become a concern for many people living in Catholic Europe in the years after Martin Luther first challenged the Church. Questioning the Pope's authority rattled the political and social structures that ordinary people depended upon. It was only five years after Michelangelo completed his complex vision of Christianity on the Sistine Chapel ceiling that Luther began publicly questioning the structure holding it all together. Luther made way for others to voice dissent on what were thought to be the fundamentals of their religion, causing Christians everywhere to question what they might have previously accepted. Would your prayers, good works, and indulgences contribute toward your salvation? Or was it as Luther said, that only unshakeable faith and God's grace determined your afterlife? Did the bread and the wine of the Eucharist really become the body and blood of Christ, or was Christ present and merely symbolized through the bread and wine?

In 1511, the year before Michelangelo finished the ceiling and six years before the *Ninety-five Theses*, Luther and a fellow Augustinian friar made the long trek on foot in winter over the Swiss Alps from Erfurt

to Rome in their flimsy monk shoes to bring a concern about the organization of their order to the central church. Luther had been excited to see the centre of Christendom, but, like many travellers with high expectations, he was deeply disappointed by the city of excess that Pope Julius II was creating with his profits from war and indulgence sales. To a monk who lived in an austere monastery in a cold northern climate, even the warm winter skies and sunshine of Rome must have seemed like an assault of sensuality.

While in the city, Luther climbed the Holy Stairs and said the Our Father on each of them. Historical anecdote has it that once he got to the top and added up the number of years this should have saved him from purgatory, he wondered, how does anyone know?

In response to all the questioning and the violence that came from Luther's disillusionment over the years that followed, the Catholic Church retreated into itself. If the Renaissance was characterized by an intellectual openness in which sacred texts were re-examined, where the past could be treated as a resource for knowing the present, the Reformation presented a threat that made the Catholic Church define its future in response. Christian humanism was characterized as a form of renewal. The Council of Trent, which convened in 1545 in what is now called Trento in Northern Italy, was meant as a Counter-Reformation but also as a Catholic Reformation, and a new form of renewal. It's stated goal was to "extirpate" heresy and to reform morals.

There would not be another Catholic reform of its size until the 1960s and the Second Vatican Council.

The Council of Trent was a forum for deciding on church doctrine in relation to the Protestant challenge. When after eighteen years it came to an end in 1563, the Catholic Church emerged as a far more conservative institution. It sought to stifle the kinds of questioning and thinking that had led to the Reformation, and this meant that it turned away from the open inquiry that had characterized the pursuits of the earlier Catholic humanists.

All the teachings of Protestantism that distinguished it from Catholicism were declared to be heresies, and the council reaffirmed Catholic doctrine by reasserting everything Luther had challenged. It reaffirmed such practices as praying to saints and venerating their relics and sacred images in churches. The problem, as the council pointed out, was not with such practices themselves, but when they were abused or performed without the proper reverence.

Though Erasmus's translation of the New Testament had initially been well received and thought to deepen an understanding of Christianity, since it corrected errors and misunderstandings from the past, the Council of Trent placed all his works on the Church's Index of Forbidden Books in 1559. Erasmus had encouraged scholars to translate the Bible into vernacular languages so that more people could read scripture for themselves. The problem with such an egalitarian seeming idea was that the translators tended to interpret and change the

scripture as they translated it to suit their own cultural or national interests. Historian Brad Gregory notes that Martin Luther's German translation of the Old Testament made it seem as though the narrative had occurred in a German setting, and that Luther also tried to cast it as the pre-story to the New Testament, leading inevitably to the story of Christ. He erased the Hebrews and made everyone sound like German Christians.

To his dismay, Erasmus became associated with Luther; his scholarly methods were equated with Luther's challenge to Catholicism. At the end of the Council of Trent, the Vulgate Bible, full as it was with the errors of Saint Jerome's fourth-century translations, was reinstated as the official version of scripture.

ON MY WAY to meet a friend for lunch one day, I decided to visit the Basilica di Sant'Agostino, where the humanist Augustinian cardinal Giles of Viterbo is entombed. Giles certainly had influence during the reign of Pope Julius II. Though there is no evidence other than proximity to suggest that he collaborated with Michelangelo on the theology behind the Sistine Chapel ceiling, certainly his thinking was known to Michelangelo. His inquisitive approach and his emphasis on going back to original sources influenced the Church of the Renaissance in the way that it included his knowledge of Plato and of Jewish mysticism.

Sant'Agostino is a big, open, and soaring space filled with paintings. There's Caravaggio's *Madonna di Loreto*

in a chapel near the left when entering, there's Raphael's depiction of a muscle-armed Prophet Isaiah. I looked everywhere for Giles's tomb, but I couldn't find it. I pulled out my phone and used the flashlight function to peer into the dark corners of chapels and at the back-sides of pillars. I found the tomb of his protégé Girolamo Seripando, but I couldn't find Giles. I asked a woman who was performing restoration work in a side chapel if she had seen his tomb. I passed her my notebook with all the possible names he might have used — Giles Antonini, Egidio da Viterbo, Giles of Viterbo. She read the names out loud and took a good look around the chapel, but she couldn't find it. I asked a disinterested man selling postcards near the entrance, but he had no idea who Giles of Viterbo was or where he might be resting.

I left, overcome with a terrible sense of regret. His idea of a religious enlightenment informed by all the great religions of the past isn't well known beyond the world of scholars. I had heard of him only in relation to his possible influence on Michelangelo and a young Giordano Bruno. The excitement he stirred up with his investigations into Jewish mysticism and his ideas on what such thought could offer Catholicism is what brought him to the Vatican in the first place. Julius II had been interested in his work. Giles himself had been put forward as a papal candidate at one point. He learned Hebrew, Aramaic, and Arabic in order to read original sources. He believed that Hebrew was the language God used to communicate with humans. And he believed

it was essential to read Hebrew literature to interpret scripture. It seemed to me that he approached spirituality as an artist, and that he used an artist's sensibility in his theology. It's the loss of his approach that I regret, that he treated his religion as though it were an artwork rather than a set of instructions.

If only, I think to myself as I walk down the wide stone stairs, knowing there's no point in getting bogged down with regret of this sort. If only, I think, knowing that time only goes forward. If only the sensibility of artists could have prevailed over the sensibility of murderous bureaucrats. Giles died in 1532, which means he would have seen the turn Christianity was taking and the violence being done in its name, but he was spared the worst of it.

When I think of Giordano Bruno being burned to death as a heretic in 1600, I think of his beautiful image of God being poured in waves, of God existing in everything, including in me. Maybe that idea is a little pagan, a little like the ancient Roman's concept of the numen, of the spirit in everything. I think of his doubts about the divinity of Christ, which is why the Catholic Church of today cannot forgive him, and I think that even there I sense a mind that I can relate to. Bruno thought of the Trinity — the Father, the Son, and the Holy Ghost — as a metaphor for one divine God with the three attributes of power, wisdom, and love rather than as three divine persons. He saw this, as an artist might have done, as an attempt to communicate something vital rather than

anything so literal. To Bruno, the Son was wisdom, and he wanted his church to be about the pursuits of the mind. To think that he was burned to death right on the spot where I often buy my spring peas and my winter cabbages for an idea that seems so poetic.

It's tempting to credit progress and the intellectual freedom to believe what we like for the fact of a statue on that spot to remind those of us who shop there of this terrible deed of religious intolerance. But it's not the kind of progress that Giles of Viterbo had in mind, and it resembles nothing that Luther wanted either. We no longer fight to the death over issues such as infant baptism or the true meaning of the Eucharist, but we've also separated the rational and scientific from the spiritual and religious. Bruno and Giles believed in God. They believed that the search for wisdom was wholly compatible with an evolving church and that such pursuits brought us closer to God. They wanted us to evolve spiritually, not to lose our religion entirely.

When I read about Bruno's ideas, that the universe is limitless, that it has no centre, that we're a part of it and connected to everything, and even when I read about his heretical thoughts on the Trinity, I felt that sensation again in my hands that I've felt in churches in Rome, in the mountains in Canada, and in the Sistine Chapel; it's a sense that I'm holding on to a feeling, a suggestion really, of something immense. It even reminds me of that feeling I had as a teenager when I saw the woman in wide pants, that feeling of being connected to everything.

I THOUGHT MY OWN ATHEISM was a choice, was
my choice. Christianity was the religion of my culture
growing up, but, like Giordano Bruno, I don't believe in
the divinity of Christ. The Christianity I saw as a child
was obsessed with small rules of behaviour, of policing
our lives for moral transgression. I had to see the Sistine
Chapel and the art of the Italian Renaissance to under-
stand that it once might have been different.

In looking at the environment that nurtured Michel-
angelo, at the Renaissance Christian humanists who
sought to investigate God through the institution of
the Church, I see that such an atmosphere of tolerance
allowed Michelangelo to create a vision of the world that
God created, a vision that included pagan history and
Jewish history, a vision that used beauty and sensuality
and love for humanity. It's possible to look at his creation
in this context and wonder where it was going to take us.
Certainly, not in the direction Christianity has travelled
since.

I think of my parents and the way the moralistic rules
of the Church made their lives so much harder, so much
worse than they had to be. I think of my mother, Mary,
suffering all those years, afraid that she had offended
God by having children with a man she loved and by
helping him to raise the children he already had.

Bruno's biographer Ingrid Rowland notes that Bruno
believed the world was made of love and that it was
filled with goodness, and that for a man who would have
seen terrible things and who himself suffered intensely,

he had little to say about evil. He spoke only of the magnificence of God.

This is why his executioners stopped his tongue so that he could not speak, so that he could not say these seductive and beautiful things and could not corrupt others with his talk of a different concept of God and the Church. They didn't see that the Church was only a structure for worship, that Christianity and its doctrines and its rituals and rules were, like the painted architecture on the Sistine Chapel ceiling, a framework meant to bring you nearer to God. The Church should have been a means to know God rather than an institution that saw itself and God as the same thing.

WHERE DOES ALL THIS leave me now, godless child of the Enlightenment that I am? I have a better sense of the spiritual vacuum in my own life, and that I've always been filling it, whether I recognized it or not, with art. It's in art that I sense the meaning in a single, finite life. That is where I glimpse the enormity of the seeming infinitude of collective life stretching forward and backward in time.

As a non-Christian, I felt that my interest in Christian art was irreverent, but now I see that believing the story of Christianity doesn't really matter. A good piece of art touches the same spiritual need in me that it does in a devout Catholic. The intensity of religious art communicates itself even to the non-religious among us because it is about our shared urge to reach up and beyond the knowable world.

When I think of the way my experience of the Sistine Chapel ceiling has deepened the more I've looked at it — that the more I've learned about the intellectual environment of the early sixteenth century, the more I've felt it to be relevant to my life — I can see that it has made me feel alive and part of something great, something *numinous*.

I like the sense of being part of the art in the Sistine Chapel, of being in the room, of looking at and thinking about the images on the ceiling and of myself as very small in relation to eternity. I like to imagine a time when I'm no longer here but it is, and someone who does not yet exist will stand where I stand now. I want to imagine that the flow of people coming to see it will continue, and that they will look up and feel a sense of greatness, feel the vastness of the universe, the unknowability of creation and of destruction and of time, and they will feel themselves a part of it too.

These frescoes represent the world that each of us is born into and that none of us created. When I look at them now, it is like looking at an ocean. I look up and feel the waves of time and events, of thoughts and questions, and I recognize myself and my existence in that moment and the existence of the others around me and I see that it is all part of a mystery that I cannot solve.

When I look at the Sistine Chapel ceiling, I can't help but feel that learning to live with opacity and complexity of the sort we encounter when we experience art such as this would be a good way to approach religion.

To see the sacred texts through a "poetic veil," as Giles of Viterbo described them, would remind us that spirituality is in a different realm from the material world, and that spiritual knowledge is attained as much through the senses as the intellect. The image of God painted on the Sistine Chapel ceiling is that of an old man, as old as time, and he is meant to help us understand in some small way something immeasurable and unknowable. God the Father is a concept whose purpose is to make an unimaginable quality tangible and relatable. The story requires a structure to help us to feel what we cannot know.

The Reformation brought legitimate grievances against the Catholic Church, which had been egregiously bending its own rules. It started as a radical response that at first sought to reform Catholicism and later sought to overthrow and supplant it with its own set of rules and oppressions. And then Protestantism quickly divided into sects that fought not only the Church of Rome but each other—Lutherans, Anabaptists, Calvinists, and more. What was lost was the vision of the Renaissance humanists and the idea of something universal. Their wide embrace of the past, of humanity, and of other ways of being and knowing has shrunk, though it still exists in the art.

THE LAST JUDGEMENT

The End of Things

When Michelangelo painted *The Last Judgement* on the altar wall of the Sistine Chapel, he was painting the end of time. This is the final reckoning, the end of the world, when Saint Peter hands the keys to the kingdom back to Christ himself. The popes and the Church no longer shape, guide, and try to prepare humanity for an eternity in heaven; they no longer try to help human souls so they don't end up with their names in the book of the damned. The work of the Church is done. At this point, each of us will have crossed that slight line between life and death.

In Italian it's called *Il Giudizio Universale*. The English title seems so blunt and hard, so unforgiving, and the concept of the "last judgement" is all those things. But *universal* judgement signifies that we're all in this together. Universal signifies the collective and grand us and not the isolated and tiny I. It speaks to everyone through time and across borders.

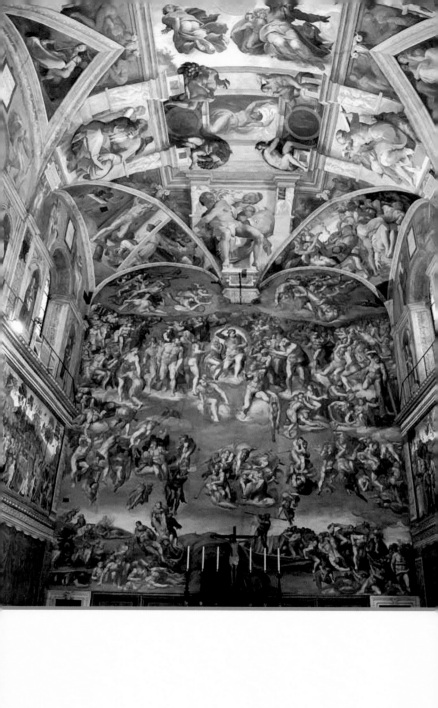

Michelangelo painted Christ in the midst of it all as enormous, broad, and blond. He is often described as Apollonian, pre-Christian, signalling that Christ is and always was. It is a nod to Michelangelo's admiration for the statue of the Apollo Belvedere with the curly hair and the youthful face. The statue, a Roman-era copy of a much older Greek bronze statue, had only just been put on display in the Belvedere sculpture court of the Vatican when Michelangelo was painting the ceiling frescoes. His portrayal of Christ also seems to reflect Michelangelo's study of the Belvedere Torso, which had been on display in the same courtyard, though he's made Christ broader and fleshier. His use of these older artistic models speaks to the integral nature of art and religion, of art as an entirely human endeavour that leads toward prayer, leads to worship. Looking at such art is a way of acknowledging the part of ourselves that wants to pray and to worship, which might have been nearer the surface of our nature in the sixteenth century. Art within religion was a means of coming closer to what we feel but can't say. It was a way to feel the presence of God. Beyond scripture, which is itself conveyed in artful, poetic language, painting and sculpture offered ways to engage the spiritual.

The universal aspect of this final judgement expands to include both the saved and the damned. There are images that reinforce Catholic doctrine over the rising and uncontainable Protestant challenges — such as the muscular angel pulling two people up to heaven by their

rosary beads, reaffirming that prayer and penitence can save a soul. But the overarching point of this fresco is that this represents all of us, the final judgement is inescapable. The universal aspect represented in the Italian title tells us that this will happen to everyone whether we believe in it or not. Painting it is a proselytizing act, the generous impulse of the believer to rescue those who would otherwise be damned.

The decisive and unsmiling Christ with his right hand up to save and his left hand down to condemn is commanding. The time for mercy has passed, but it hasn't passed yet for those of us standing in front of the fresco studying it. Within the painting there's an urgent need to communicate something important; nothing less than eternity is at stake.

The Catholic world believed that Christ would judge us as either worthy or unworthy. Most of the major religions have this idea of judgement day. It's as though we need containment or an end-point because earthly eternity is unthinkable. If there was a beginning, there must also be an end. The problem that was emerging during this period of Christianity was that the rules for salvation no longer seemed clear. Was it possible that, acting in good faith, a Christian could still do the wrong thing and end up paying an eternal price? Could it be that buying an indulgence to pay for the reconstruction of Saint Peter's Basilica would not speed the soul's journey through purgatory? Could the spiritual laziness inherent in such a transaction damn a soul eternally?

Certainly, the early Protestants thought so. Is it possible that the flexible papal interpretation of God's will that helped to fuel the Renaissance was a pathway to hell?

These were important questions raising important doubts in the sixteenth century, world-changing doubts.

An obvious change happened between the time the young painter worked on the ceiling and the much older man created *The Last Judgement*. No one could pretend that things were as they had been. The Sack of Rome altered everything. *The Last Judgement* is not about the soaring heights of Christianity and the human possibilities within it. This painting is about petty, human failure, the waste of it all, the harsh and final end.

Those who have been chosen to go to heaven seem almost inconsequential, off they rise safely up and into the blue. Michelangelo depicts a few struggles; an angel pulls a man upward by his legs while a demon grips the man's arms and tries to pull him back into the ground. For the most part, heaven appears as if it can take care of itself; it's the cringing and flinching of the damned that have most of the artist's attention.

The Sack of Rome was a kind of hell on earth and it, along with the pressure brought on the Church by the questions raised by Luther, creates tension between the work on the ceiling and this one on the altar wall. It must have seemed apocalyptic to have had a raid on the centre of Christendom by Christians. The enemy was supposed to be outside and beyond and then here

it was within the walls. A rush of men who thought they were routing out the Antichrist in the papacy destroyed the city and murdered as many of its heathen inhabitants as was possible.

Michelangelo wasn't in Rome when the violence happened, so he didn't witness it. But he saw what had happened to the city and to the people who served within his religion. One-fifth of Rome's population was murdered. And then the plague swept through, killing even more, including some of the soldiers, so that the city-state's population was reduced to one-third by the time it was all over. Michelangelo didn't portray the act of violating Rome. It's more the effect the violation had on him that comes through, and the effect of his concerns about the new Protestant assertions concerning faith and penance. Catholics of his generation had to face the corruption of their Church, and they had to consider how this might affect their own salvation. Such doubts and concerns about the Church's practices had been raised more respectfully even before Luther by others like Erasmus, and earlier somewhat less respectfully by Girolamo Savonarola in Michelangelo's own home-town of Florence. Certainly, by the time he painted *The Last Judgement*, Michelangelo was well aware of the substance of Luther's challenge to Catholicism. And the current of change that would cause the Catholic Church to have its own reformation was obviously moving through Michelangelo with his more

sorrowful approach to the condition of man. Although there's little to support the truth of this story, it is said that Pope Paul III dropped to his knees to pray before the fresco when he first saw what Michelangelo had painted and was heard to say: "Lord, do not charge me with my sins when you come on the day of Judgement."

It's the effect of the violence on the artist that I sense. It's the effect of the art on those who did violence that I also recognize. It's not that they were moved by what they saw, but that they knew the art was important, that it contained something of the corruption of the Catholic Church, and they wanted to destroy it. That's something from their world that has travelled to mine, that anger and that fear hasn't changed.

In Michelangelo's depiction of the damned, the abandonment of hope and the sense of failure and disappointment come across clearly. Unlike his sympathetic portrayal of God's sinful victims in *The Deluge*, Michelangelo lingers on the suffering of those who disobeyed God's laws (including in the lower right a satisfying bit of revenge in the form of a portrait of one of the pope's aides, who complained about the nudity while the fresco was being painted, whom Michelangelo portrayed as Minos naked and with a large snake wrapped around him and biting his genitals). Michelangelo's hell seems more a story of sadness for those who failed to live up to those laws. There is also sadness for his own youthful arrogance and failure to recognize the corruption around him.

Where the younger Michelangelo painted God creating the world in a position similar to his own reaching and twisting to paint the ceiling, in *The Last Judgement* he chose to paint his own likeness on the face of the flayed Saint Bartholomew that dangles over hell like a gruesome party costume. This flayed figure has also been identified as Marsyas, who arrogantly challenged Apollo, the god of music, to a musical contest and was afterwards skinned alive for his egotism. As he aged, Michelangelo likely saw his own youthful confidence in his "divine" abilities as provocative to a god who would inevitably judge him. In painting his own face into the story in such a way, it seems he was judging himself.

While I stand in front of this massive portrayal of the saved and the damned and look squarely at Christ's sculptural torso, I can only think, once again, of Rilke and "The Archaic Torso of Apollo." The poet shifted the poem's perspective so that he was no longer observing the object but being observed through it: "for here there is no place that does not see you." Is this what he means? To be observed in this sense, to be unable to hide from the universe? To recognize that existential fear as something ancient and inevitable? "You must change your life." The Church tried to provide a pathway to goodness. In art we feel the command just as forcefully, but the question of how to change our lives is left unanswered. It's only in living our lives that we figure it out.

MICHELANGELO WAS SAID TO have admired Luca Signorelli's version of the last judgement, which Signorelli began in 1499 in the Umbrian hill town of Orvieto. Signorelli had been asked to finish the work begun in the 1440s by Fra Angelico, where the older painter had placed Christ at a central point and above a window in the San Brizio Chapel in the Orvieto Cathedral.

But Signorelli's contribution to the work in this chapel is significant for having been started during a period of apocalyptic end times. When I looked carefully at Michelangelo's version, I wondered if he hadn't absorbed some of Signorelli's end-of-the-world anxiety. For Signorelli, the calendar wasn't just turning over a new century or half-millennium, it wasn't just another year but another world on the other side of that number.

My son and I took the train to Orvieto to have a look. I had wanted to see if I could get a sense of that anxiety first before going back to the Sistine Chapel. It was another of those hot and too quiet summers in Rome, and since Nicolas was now a teenager, he was a little more interested in making the trip. Apocalyptic end times sounded good to him.

The small hilltop city was quiet when we arrived that morning, since the relentless sunshine tends to keep people indoors. We tried to stay in the shade as we followed the road upward, practically hugging the dark stone walls, and went straight to the Cathedral.

We were relieved to go inside, to be out of the heat and into the cool, dim, and cavernous church. We let our

eyes adjust to the low light before we found the San Brizio Chapel. To Nicolas's great relief, it is not a big room, and it is almost cheerfully bright compared to the dark nave of the cathedral itself. I stood at a distance to get a sense of the space. Signorelli had to work around windows and arches and to incorporate the older fresco of Christ above the window. My son, however, went straight to Signorelli's *Preaching of the Antichrist* on the side wall, since it is the most bizarre and interesting thing in the room.

The world was changing in 1499. Causes were having effects. One thing did lead to another. The excesses of the Church, the opulence, the money-lending Medici in Florence, and the indulgence-selling popes in Rome were the objects of some spiritual concern. In the late 1400s in Florence, Girolamo Savonarola, the Dominican monk who foreshadowed Martin Luther, questioned the path of the Church and even of the artists who had grown so fond of luxury. He felt they had lost their way, that they were allowing evil into their world through their love of beauty and riches, through their irreverently sensuous portrayals of the Virgin Mary, through their loss of Christian discipline.

The Gospels warn of false prophets, and Savonarola warned of them too. But then he was accused of being one, as the Church turned his warnings against him.

He died a heretic's death in 1498 in the square in Florence that is today surrounded by restaurants and leads toward the Uffizi Gallery. He was hanged and then burned there on the spot with two fellow heretical monks.

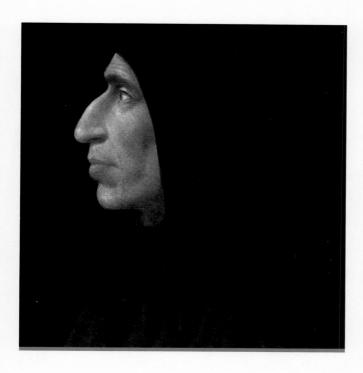

There's a plaque in among the paving stones to acknowledge the act.

Savonarola preached about the corruption of the clergy and the exploitation of the poor and the faithful. He held the infamous bonfires of the vanities in Florence, where he and his followers collected art, books, jewellery, and expensive clothing and burnt them as a way of repudiating the worldly goods that could only tempt a good Christian into sin. Savonarola warned of a new

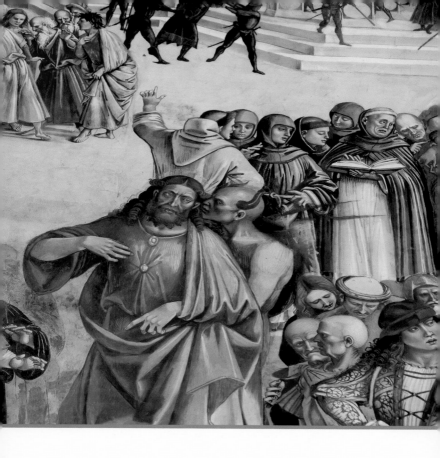

flood on its way to wipe the Earth clean of sinners once
again, and of reform that would come from the north.
Of course, the rise of Luther from Germany nearly
twenty years later would seem like the realization of
that prophecy, just as the Sack of Rome must have
seemed like the apocalypse to those who experienced it.

His powerful and ascetic view of the religious life of citizens was gaining popularity and becoming an unsettling force in Florence. But the Church sought to settle it with that bonfire of their own. Luca Signorelli began painting in the Orvieto Cathedral the year after Savonarola's death. His depiction of the Antichrist confirmed the Church's position on false prophets and the danger they presented to the faithful.

At first glance, *The Preaching of the Antichrist* appears to be arranged like many other religious works of its time, with a church in the background, some details of the landscape and robed men gathered around an action in the foreground. It's arranged in a way that is not so unlike Perugino's *The Delivery of the Keys to Saint Peter,* painted on the wall of the Sistine Chapel twenty years earlier. But where Perugino's painting shows Christ giving Saint Peter the keys to the kingdom of heaven, in Signorelli's painting there is something seriously wrong with the Christ-like figure standing on a pedestal and surrounded by a group of agitated men and women. The figure is stiff and wild-eyed and is being worked like a puppet by an orange-skinned devil with red horns coming out of the sides of his bald head. The arms of the demon have slipped through the false proph-et's robes so the two have been made into one being.

What was likely most frightening to viewers at that time was that the Antichrist appeared to have entered their religious world as a clergyman. In speaking against the Church, Savonarola and his heretical ilk were thought

to be leading people dangerously astray. A painting like this, one of the few known depictions of the Antichrist, would have been a frightening warning. To a viewer in the twenty-first century it looks like allegory, but Christians of that time believed that angels and demons both lived among them. This painting depicted a kind of reality that is hard for us now to imagine.

For a contemporary visitor who knows the history of what unfolded next, it's possible to see Signorelli's painting as representing the very fears of Savonarola, and then those of Luther. Less than twenty years later, Luther was saying that the situation actually was as Signorelli had portrayed it. But it wasn't simply a preacher in a square; it was the representative of God on earth, the pope himself, who had fallen under the influence of Satan, condemning all Christians to an eternity in hell.

It starts to become impossible to keep track of who will lead us to heaven and what will send us to hell.

By the time Michelangelo began painting his *Last Judgement*, thirty-seven years after Signorelli began painting his, the correct path to eternal salvation was in doubt. Pope Paul III's decision to have Michelangelo paint this subject could be understood as the Church trying to reaffirm its position, while it also reveals the fears of the painter. It is propaganda, it is frightening, and it carries a sense of anxiety, of ancient fears that resurface again and again and again. It is our fear of the dangerous, dark malevolent force that claims to be doing good in the world

when it is really spreading evil. It's the eternal problem of evil in a world created by the god of goodness.

It makes me think of my mother and her fears toward the end of her life. She was afraid that her rejection of her Church in favour of her heart and her family would not only condemn her soul but the souls of her children and grandchildren too. While sitting on our balcony in Rome, sipping iced tea in the mid-September warmth of what was her last visit to Italy before she died, she told me that she was sorry she had not baptized me, and she asked if I would consider doing it now. She begged me to talk to James and to take Nicolas, who was nearly three at that time, to a priest.

I suggested that she talk to a priest herself, to see if someone could help her find a way to make peace with her religion and her own sense of spirituality, which had obviously never left her. She murmured her usual objections and her fear of facing the disapproval of a priest, of the Church, and of God.

Then, when we talked on the phone just before Christmas that same year, she told me that after she returned home, she continued to think about making a confession. Finally, she went to the Catholic church near her apartment in Toronto and asked to speak to the priest. To her surprise and delight, he was African. She knew immediately, she told me, that this was not the Church of her youth. She hoped that this man, who she assumed must have had a different life from the priests she once knew, who must have knowledge of a different

kind of Catholicism, might understand her. She told him everything.

After Nicolas and I left the cathedral in Orvieto and headed toward a trattoria for a plate of pasta, Nicolas said he found it hard to imagine that the changing half millennium brought with it so much terror. He spoke about it objectively, incredulous that their fear of damnation was so great. He spoke as a true inheritor of the Enlightenment, without the slightest sense that the fears of a sixteenth-century Christian, fears of damnation, would ever be his. I wondered how my mother would have felt about his attitude. Would she have been grateful that he didn't experience an oppressive Church, or would she be sorry for him to miss out on the shared spiritual experience of belonging?

My mother told me that when she finally made her confession, the priest asked her if she loved her children and her grandchildren. She said she did, very much. He asked if she regretted giving life to any of her children, and she told him that she did not regret any of us. The priest told her that this was good because not loving her children would have been a sin.

"What else did he say?" I asked her.

"He asked me to say a prayer with him," she said. "And he gave me some tasks to perform. But they're private."

"Between you and God?"

"Yes."

"Any Hail Marys?"

"Quite a few," she said.

WHEN I WENT TO THE Sistine Chapel the winter after
Nicolas and I had been to Orvieto, I asked him to come
with me, but he really didn't want to see it. He finds the
Reformation very interesting and has been intrigued
by the fact that his father's family is Lutheran and his
mother's is Catholic. He was amused when I told him that,
while his father and I were visiting one of Rome's more
important churches, I exclaimed over the rich history
of the artwork, over the fact that every doorknob and
banister was laden with symbols, while James was mainly
appalled by the excess. We unwittingly absorb these ideas
and feelings and express them thinking they're our own.

Nicolas finds the religious art that we see all around
us to be both familiar and meaningless. His moral
compass is being developed through a secular education,
through the society he lives within, and through his
family. His sense of spirituality is grounded in this
mortal life; it's these years that he lives that matter and
not any idea of an afterlife. And I wonder how all of that
will affect his experience of art in the future. It's neither
good nor bad, it's just what he will bring to it.

So, I went, as I usually do, by myself. And I realized
that Robert Hughes's advice, which I had taken on my
first visit, to look at the artwork in front of me, to quietly
observe and notice the details, was really the only way
to look at the Sistine Chapel frescoes or any work of art.

When I entered the room this time, I tried to acknow-
ledge everything I was bringing with me. There's my own
past and the sensory memories I have of Catholicism that

I wasn't fully aware of before, there's the sense of rage that I sometimes feel around me in the room that connects again to my past, and there's the slight and involuntary twinge of fear that this rage provokes in me. I've also brought my current life in Italy into the room with me as well as the various historical threads I've followed over the last few years. It all comes with me now.

This time, as I looked around the room, I realized that I hadn't understood any of that until I saw this. Until I saw the Sistine Chapel, so many of my feelings and half-memories were disconnected. And if I didn't have the particular experiences that I've had, I would have looked at these frescoes differently. We don't encounter art as a blank slate.

Also, on this occasion, I recognized that it is just a room. As paying guests of the Vatican Museum, we're allowed to enter it and look around. It still has a function within the Vatican itself as the room where the popes have been chosen for centuries. It was used for this purpose long before Michelangelo made it famous. It's still where a select group of clergy pray. It's even used occasionally for concerts. It has a function apart from the artwork. And if Pope Adrian VI, who became head of the Church in 1522, had not died in 1523, he would have had the ceiling painted over to wipe away the nudity and the paganism that he found so offensive. There would have been no call for Michelangelo to paint *The Last Judgement* on the altar wall. And I wouldn't have considered any of the things that have been occupying

my thoughts since I first glimpsed the void on my much earlier visit, when I was able to sit down, look up, and see *The Deluge*.

It is just a room, but it feels like its own universe. All the learned scholars and artists and writers who have been here and pronounced Michelangelo's frescoes to be great have added weight to the experience of the images.

It is also hard to see the chapel as a piece. It took me a long time to stop looking at the parts of the ceiling and consider it as a whole. Considering *The Last Judgement* as part of this whole was another exercise in learning to look.

Making repeated visits to a single piece of art deepens the experience. A single painting can reveal itself over time when it's given enough attention. An entire room such as the Sistine Chapel demands more time than most of us have to spend. It could easily occupy my life. On one visit, I couldn't find Jonah. I made myself dizzy spinning around until I finally found him directly above *The Last Judgement* with his feet dangling over the room, sitting there on one of those marble-looking ledges, a big fish tucked in beside him.

This work is like the world, so varied and so beautiful in places, and so much like a person's life with links and lines and stories. It is impossible to take it in as a whole except for here and there in flashes so brief that they're gone almost before they've had time to register. The mystery of my own reaction is what sends me back to see it again.

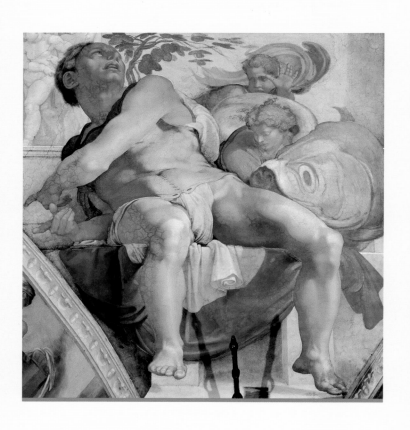

Such as it did on that winter morning when the soft light filtered through the upper windows and when I turned quickly toward the exit and had a sudden, fleeting feeling of the room itself as a single piece of art. Michelangelo dominates the artistic space, but it involves more than him.

The frescoes already on the walls before Michelangelo painted the ceiling tell mirroring stories from the Old and the New Testament. Sandro Botticelli painted the portraits of the popes between the windows. The structure of the room had to be worked with and worked over. The building itself was designed before Michelangelo ever got to it and the architecture had to be accepted and brought into his scheme.

There is the grand ceiling with its layers of human knowledge. There is the Christian rendering of the great unknown realms of death and eternity. It felt for a second like one piece. While I was standing there trying to prolong the moment, a priest asked for silence and began to pray. He spoke in Italian and yet he was speaking for all of us regardless of our language, the familiar rhythm of prayer. And then there we were, all of us confused people wandering around in the room, unsure where to look, or what to do, or to think, or how to be. We are also represented here within this work, and we are part of it. In that quick sweeping look around the room, I got a sense of something contained in that space, something that made sense there, and it included me; it included all of us.

I DON'T REALLY HAVE any sense of Michelangelo as a person, as a human being. To me, he is the vessel, the medium. Maybe it's just that so much time has passed, that after five hundred years the work really is more important than the person who made it. It has endured and outlasted its creator, who died in 1564. He is of his time, but his artwork continues to mean something well beyond his time. He had an extraordinary natural ability that he developed with his teachers, although he liked to say that he'd emerged fully formed as the artist he was from the head of the divine.

But he's so distant and seemed to be so devoted to his work to the exclusion of all else. It's his work that is important. He didn't have a partner. He had no children. He simply made art for God.

In *The School of Athens*, Raphael painted the figure of Heraclitus with the features of Michelangelo. It's not a disrespectful portrait, even though they were rivals painting at the same time, competing for the pope's favour. Raphael portrayed Michelangelo as a puzzler, a thinker, a man trying to touch a part of the mystery and to transmit it so that we could sense it too. It's the mystery of being, of existing, and the mystery of what it means. I usually stop in the Raphael rooms to see that painting and that image of Michelangelo before I enter the Sistine Chapel. He's a man apart. He's alone, separated from the other artists, from Leonardo, depicted as Plato behind him, and Bramante as Euclid across from him, and also

from Raphael himself, looking out from the corner
at the viewer's right. So that when I finally enter the
Sistine Chapel and contemplate the ceiling and *The
Last Judgement* on the wall, and if I think of the man
who created it, who thought it into being, I think of
Raphael's picture of Michelangelo.

Of course, it doesn't matter what he looked like.
The biographical facts of his life matter more, certainly
the historical context, the period in which he painted
matters greatly. But nothing matters more than his
intention, his deep focus and effort to transmit some-
thing of the place where art and religion come from.
His willingness to dig into this fundamental part of
himself and to assume that it is so for the rest of us is
what makes this work so important.

When a person like me stands five hundred years
later staring at his artwork, though it can take some
time, it can take quite a lot of time and thought, it's
possible to sense that intention. Whatever his searching
and seeing brought to him, he has tried to bring to us.

In searching for something to help explain what
it feels like to receive what Michelangelo has left us,
I was reminded of the concept of "el duende." I read
about it in the last book John Berger published before
he died. El duende is multifaceted and indefinable. It
exists among artists, and particularly among flamenco
singers and dancers. They describe it as the wind
that could sometimes sweep through a performance
affecting performers and audiences alike. "Duende is a

ghost from the past," writes Berger. "And it's unforget-table because it visits the present in order to address the future."

Poets invoke el duende as well, as a force that enters them and their listeners at a reading, enabling rhythm and metaphor to be understood without the effort of thinking. Berger quotes Federico Garcia Lorca, who described el duende at a lecture in Buenos Aires in 1933 as an element outside the performers' conscious control: "and at every instant (it) works the arms of a performer with gestures that are the mothers of all the dances of all the ages."

Lorca also said in his lecture that el duende "is a power, not a work. It is a struggle, not a thought. I heard an old *maestro* of the guitar say, 'The *duende* is not in the throat; the *duende* climbs up inside you, from the soles of the feet.' Meaning this: it is not a question of ability, but of true, living style, of blood, of the most ancient culture, of spontaneous creation."

That's why I come back, I think, to the Sistine Chapel to stare, mostly at the ceiling, but also at the rest of it. It's hard sometimes to remember my original feeling of hesitation, what brought me in the first place, what made me overcome my initial sense that this room of art was too much for me. But this is why I come back. This sense of the ghosts of the past, of the ancient gestures signal-ling and repeating urgently and calling out something that I can't quite hear, can't quite understand, but that I can feel.

WE ALL BELIEVE different things now. I don't know
what to believe, or even if faith and belief are possible
for me. I only know what I feel when looking at art,
when thinking about a piece of art. When thinking
about this work of art, I feel connected to the lost things
of the past, and through this art I feel connected to a
future I will never experience.

I walked out to the street afterwards and around to
the piazza in front of Saint Peter's among the thousands
of tourists visiting Vatican City, thousands of people
searching and seeking. I saw a woman drinking from
a water bottle with her eyes closed against the sun,
a child fidgeting while his father checked directions
on his phone. The child caught my eye, and I smiled.
He went still and stared back expressionlessly. I saw
pigeons edging toward a couple who had stopped under
Bernini's colonnade to eat sandwiches. I saw the enor-
mous seagulls of Rome swooping in on the pigeons.

I felt something, some vestigial thought beyond the
impulse to make sense of the world and the unknown.
I felt emotional, I felt time passing, I saw the scene
before me shift and become something else. The woman
and her water bottle already disappearing into the
crowd, the child and his father on their way to wherever
his phone was taking them, other people filling their
spaces momentarily and then moving on. The enormous
basilica of Saint Peter's was at my back, an engineering
marvel of its time, of any time, built quite possibly out
of the souls of early-sixteenth-century Christians.

To create art is an act of faith, faith in a continuous, changing, sometimes regressive and sometimes evolving flow of humanity. Without the viewer, it is meaningless. We bring meaning to it as it reflects us to ourselves.

Art has been used to reflect power and prestige. It's been used as instruction and propaganda. It entwines itself with the corrupting influence of money, too, but none of that can obscure the effect of art on the person looking at it. The original impulse behind a fresco or a poem is to touch something in the viewer or the listener, to pass something along, a whispered message, to be carried by the wind through time. To be carried by the ones who feel that slight breeze, who glimpse the ancient gestures, and who stop and look.

The Sistine Chapel frescoes, ostensibly about the unseen reality of God and eternity, require the human presence, the attention of the viewer. And it is in this way that their meaning enters the world and touches people who have never even seen the real thing, touches a woman born into a family of fur trappers in North Bay, Ontario, who becomes connected to the art by the faith she shared with Michelangelo, and then flows almost wordlessly through her children and their children, mirroring the spiritual but apart from it, urging obliquely and indirectly that attention be paid to life through art. Michelangelo's Sistine Chapel frescoes come from a time when art held an almost mystical power over us, and even now it's still possible to feel it.

The impulse to make art is one thing, but the impulse to experience it is something else entirely. Art answers a human yearning, a basic need to engage at a level beyond the rational and beyond the spiritual. It isn't religion, it has no doctrine, and while it changes over time, in its larger sense, it isn't exactly man-made, no more than the clouds above us. No more than the crowd in the piazza is made by someone, I thought to myself as I stepped from under the colonnade and walked out among the others.

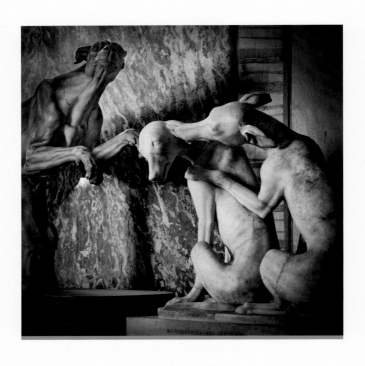

Acknowledgements

What happens when you look deeply at a work of art? I thank Tim Falconer for thinking the question was interesting enough to pursue as an essay at the Banff Centre for Arts and Creativity, for guiding me through that first essay, and for encouraging me to take it further. I'd also like to thank Ian Brown for his editorial guidance while at the Banff Centre, and Charlotte Gill for hers. The three of them — Tim, Ian, and Charlotte — created an atmosphere of creative camaraderie that gave me and my fellow writers in the Literary Journalism fellowship the opportunity and inspiration we needed to throw out the rules, write with abandon, and then reimpose a few rules as we returned to reality. Enormous thanks to the Banff Centre for Arts and Creativity for providing such an extraordinary opportunity.

Thank you to Elizabeth Witte for her interest and her work in helping me to shape a version of that original essay for *The Common*.

I'd really like to thank Jackie Kaiser of Westwood Creative Artists for being such a marvellous literary agent and human, for saying "I'm listening" when I first told her I had an unusual idea for a book, for encouraging me when I needed it, for reading multiple drafts, and for helping me to find the shape of the story.

It's possible that Daniel Wells of Biblioasis has read this book more times than I have, and I thank him for his careful editing and for egging me on. I am grateful to him for liking it in the first place and then for helping me to make it so much better. I am also grateful to Vanessa Stauffer at Biblioasis for all her work on the book. I liked knowing that a poet was watching over the process. Rachel Ironside made it all that much better and cleaner with her sharp eye for detail, and Natalie Olsen made it into a beautiful object.

Moira Egan read an early draft and gave me helpful comments. I thank her for that and for all the literary chats we've had over the years accompanied by lunch or aperitivo. Andi Shiraz also read and commented on an early draft, and I thank her.

Agnes Crawford, who knows Rome and the Vatican Museums better than the pope, gave the manuscript a historical once over and corrected some errors — any remaining errors are all mine.

My friend, Douglas Anthony Cooper, a fellow Torontonian whom I've only ever known in Italy, brought his photographer's eye to the project and captured the melancholy and the grit of Rome. I thank him not only for his hard work but also for capturing in pictures the things I tried to say in words. Thanks also to Jim Panou, an extraordinary photographer and even more extraordinary friend, who always had a way of capturing the essence of my son when he was little.

I am so grateful to my family, starting with my

husband, James Heer, who encouraged me from the beginning, talked over details of history and elements of style, and gave the whole thing a thorough read-through, several times. My son, Nicolas Heer, continues to inspire me with his wide-ranging interests, his insight, and his willingness to accompany his mom to see art that he mostly doesn't care for ... not yet, anyway.

I offer love and thanks to my siblings — Dan, David, and George. Also to the ones who are gone — Ken, Marion, Bob, Bill, and Sandra. I have to thank Danny in particular for loving a good argument and also for going with me to the Uffizi Gallery in Florence, becoming captivated by the Renaissance artwork he saw there, and making me be the one to drag him out of the gallery and into a bar.

I especially thank my mother, who talked in riddles about Catholicism, art, deception, and violence, and who did her best to say the unsayable for most of her life. And, of course, I thank my granny for telling me about Michelangelo and the Sistine Chapel frescoes in the first place.

Sources

Alberti, Leon Battista. 2004. *On Painting*. Translated by Cecil Grayson. (This translation first published by Phaidon Press 1972. First published in 1435.) London: Penguin.

Barolsky, Paul. 1997. "Looking Closely at Michelangelo's Seers." *Notes in the History of Art* 16, no. 4.

Berger, John. 1972. *Ways of Seeing*. London: Penguin.

———. 1985. *The Sense of Sight*. New York: Pantheon Books.

———. 2016. *Confabulations*. London: Penguin.

Campbell, Stephen J., and Michael W. Cole. 2012. *A New History of Italian Renaissance Art*. (Corrected edition 2013.) London: Thames & Hudson.

Chamberlin, E. R. 1979. *The Sack of Rome*. London: B. T. Batsford.

Danto, Arthur C. 2002. "Barnett Newman and the Heroic Sublime." *The Nation*. June 17, 2002. thenation.com/article/archive/barnett-newman-and-heroic-sublime.

Dotson, Esther Gordon. 1979a. "An Augustinian Interpretation of Michelangelo's Sistine Ceiling, Part I." *The Art Bulletin* 61, no. 2.

———. 1979b. "An Augustinian Interpretation of Michelangelo's Sistine Ceiling, Part II." *The Art Bulletin* 61, no. 3.

Freedberg, David. 2016. "The Fear of Art: How Censorship Becomes Iconoclasm." *Social Research* 83, no. 1.

Gingerich, Owen. 1982. "The Galileo Affair." *Scientific American* 247, no. 2.

Graham-Dixon, Andrew. 2008. *Michelangelo and the Sistine Chapel*. London: Weidenfeld & Nicolson.

Gregory, Brad S. 2017. *Rebel in the Ranks: Martin Luther, the Reformation, and the Conflicts that Continue to Shape Our World*. San Francisco: HarperOne. (I relied heavily on this for information about Martin Luther and the Reformation.)

Handwerk, Brian. 2021. "45,000-Year-Old Pig Painting in Indonesia May Be Oldest Known Animal Art." *Smithsonian Magazine*. January 13, 2021. smithsonianmag.com/science-nature/45000-year-old-pig-painting-indonesia-may-be-oldest-known-animal-art-180976748.

Hirsch, Edward. 1999. "The Duende." *The American Poetry Review* 28, no. 4: 13–21.

The Holy Bible. King James Version. Arranged and Edited by Ernest Sutherland Bates. (1993 edition.) New York: Simon & Schuster.

Hughes, Robert. 1980. *The Shock of the New: Art and the Century of Change.* (Corrected edition 1981.) London: British Broadcasting Corporation.

———. 2011. *Rome.* (Phoenix Paperback edition.) London: Orion Books

Innocenti, Claudia, Giulia Fioravanti, Raffaello Spiti, and Carlo Faravelli. 2014. "La sindrome di Stendhal fra psicoanalisi." *Rivista di psichiatria*, 49(2). https://www.rivistadipsichiatria.it/archivio/1461/articoli/16139/

Kant, Immanuel. 1960. *Observations on the Feeling of the Beautiful and Sublime.* Translated by John T. Goldthwait. (First published in German in 1764.) Berkeley: University of California Press.

Jan de Jonge, Henk. 2016. "The Sibyls in the Fifteenth and Sixteenth Centuries, or Ficino, Castellio and 'The Ancient Theology.'" *Bibliothèque d'Humanisme et Renaissance* 78, no. 1. Paris: Librairie Droz.

King, Ross. 2003. *Michelangelo & the Pope's Ceiling.* New York: Bloomsbury.

Kristeller, Paul Oskar. 1979. *Renaissance Thought and Its Sources.* New York: Columbia University Press.

Lerner, Ben. 2013. "Damage Control: The Modern Art World's Tyranny of Price." *Harper's Magazine.* harpers.org/archive/2013/12/damage-control.

Leroux, Neil. R. 2003. "'In the Christian City of Wittenberg': Karlstadt's Tract on Images and Begging." *The Sixteenth Century Journal* 34, no. 1: 73–105.

Livio, Mario. 2020. "Did Galileo Truly Say, 'And Yet It Moves'? A Modern Detective Story." *Scientific American.*

Longinus. 1945. *On the Sublime.* An English translation by Benedict Einarson and Sir Joshua Reynolds, Discourses on Art. Chicago: Packard & Company.

Lorca, Federico García. 1998. "Play and Theory of the Duende." In: *In Search of Duende.* Translated by Christopher Maurer. (Lecture first delivered in Spanish in 1933.) New York: New Directions.

Magherini, Graziella. 2019. Video interview with Dr Graziella Magherini. European Humanities University annual symposium in Florence. youtube.com/watch?v=cgIv-OpqDbs.

Marciari, John. 2017. *Art of Renaissance Rome: Artists and Patrons in the Eternal City.* London: Laurence King Publishing.

Martin, F. X. 1959. "The Problem of Giles of Viterbo: A Historiographical Survey; Part 1." *Augustiniana* 9, no. 4: 357–379.

———. 1960. "The Problem of Giles of Viterbo: A Historiographical Survey; Part 2." *Augustiniana* 10, no. 1 / 2: 43–60.

Massing, Michael. 2018. *Fatal Discord: Erasmus, Luther, and the Fight for the Western Mind*. New York: Harper. (I relied heavily on this for information about the Reformation.)

McHugh, Heather. 1994. "What He Thought." In *Hinge & Sign: Poems, 1968–1993*. Middletown, Connecticut: Wesleyan University Press. Used with the permission of the author.

Mikhail, Alan. 2020. *God's Shadow: The Ottoman Sultan Who Shaped the Modern World*. London: Faber & Faber.

O'Malley, John W. 1968. *Giles of Viterbo on Church and Reform*. Leiden: E. J. Brill.

Parks, Tim. 2006. *Medici Money: Banking, Metaphysics and Art in Fifteenth-Century Florence*. (First published in 2005.) London: Profile Books.

Pascoe, Louis B. 1966. "The Council of Trent and Bible Study: Humanism and Scripture." *The Catholic Historical Review* 52, no. 1: 18–38.

Pater, Walter. 2014. *The Renaissance: Studies in Art and Poetry*. (First published in 1873.) Mineola, New York: Dover Publications.

Reyburn, Scott. 2022. "Magritte Sets Record With $79.7 Million Sale at Sotheby's." *The New York Times*. nytimes.com/2022/03/02/arts/design/magritte-auction-sothebys.html.

Rilke, Rainer Maria. 1995. "Archaic Torso of Apollo." In *Ahead of All Parting: The Selected Poetry and Prose of Rainer Maria Rilke*. Edited and translated by Stephen Mitchell. (First published in German in 1908.) New York: Modern Library. poets.org/poem/archaic-torso-apollo.

Roskill, Mark (ed.) 1963. *The Letters of Vincent van Gogh*. (The translation from which this selection has been made was first published by Constable & Co. in 1927–29.) London: Fontana/Collins.

Rowland, Ingrid D. 2008. *Giordano Bruno: Philosopher/Heretic*. Chicago: The University of Chicago Press.

Ruggiero, Guido. 2015. *The Renaissance in Italy: A Social and Cultural History of the Rinascimento*. New York: Cambridge University Press.

Shakespeare, William. 1986. *The Sonnets and A Lover's Complaint*. Edited by John Kerrigan. (From a volume that first appeared in 1609.) London: Penguin Books.

Spicer, Andrew. 2017. "Iconoclasm." *Renaissance Quarterly* 70, no.3: 1007–1022.

Stendhal. 2010. *Rome, Naples and Florence*. Translated by Richard N. Coe. London: Calder Publications.

Tucker, Abigail. 2012. "How Does the Brain Process Art? New Imaging Techniques Are Mapping the Locations of Our Aesthetic Response." *Smithsonian Magazine*. November 2012. smithsonianmag.com/science-nature/how-does-the-brain-process-art-80541420.

Vasari, Giorgio. 1998. *The Lives of the Artists*. Translated by Julia Conaway Bondanella and Peter Bondanella. New York: Oxford World's Classics.

Visser, Margaret. 2000. *The Geometry of Love: Space, Time, Mystery, and Meaning in an Ordinary Church*. Toronto: HarperFlamingo Canada.

Wallace, William E. 2010. *Michelangelo: The Artist, the Man, and his Times*. New York: Cambridge University Press.

———. 2019. *Michelangelo, God's Architect: The Story of His Final Years and Greatest Masterpiece*. Princeton, NJ: Princeton University Press.

Wanted in Rome. 2017. "French Policewoman Vandalises Colosseum." *Wanted in Rome*. wantedinrome.com/news/french-policewoman-vandalises-colosseum.html.

Waterworth, J. (ed. and trans.). 1848. *The Council of Trent: The Canons and Decrees of the Sacred and Oecumenical Council of Trent*. (Originally publication, London: Dolman.) Hanover Historical Texts Project Scanned by Hanover College students in 1995. documenta catholicaomnia.eu/03d/1545-1545,_Concilium_Tridentinum,_Canons_And_Decrees,_E N.pdf.

Weil, Simone. 1970. *First and Last Notebooks: Supernatural Knowledge*. Translated by Richard Rees. Eugene, Oregon: Wipf & Stock.

Weinstein, Donald, ed. 1965. *The Renaissance and the Reformation, 1300–1600: Sources in Western Civilization*. New York: The Free Press.

———. 1979. *Savonarola and Florence: Prophecy and Patriotism in the Renaissance*. Princeton, NJ: Princeton University Press.

Whittaker, Thomas. 1884. Giordano Bruno. *Mind*. Oxford University Press.

Williams, William Carlos. 1938. *The Collected Poems of William Carlos Williams, Volume I, 1909-1939*. Edited by Christopher MacGowan. New York: New Directions. poetryfoundation.org/poems/45502/the-red-wheelbarrow.

Wind, Edgar. 1968. *Pagan Mysteries in the Renaissance: An Exploration of Philosophical and Mystical Sources of Iconography in Renaissance Art*. (Originally published 1958.) New York: W. W. Norton.

Wisan, Winifred Lovell. 1986. "Galileo and God's Creation." *Isis* 77, No. 3 (September 1986): 473–486.

Image credits